The New Colourful Home

Written and compiled by Emma Merry
Photography by Neil Perry

HOXTON MINI PRESS

Emma Merry is a colour consultant and founder of Home Milk – an interiors platform where everyone is welcome. She aims to increase people's confidence when it comes to using colour in their homes, creating environments that improve wellbeing. Through inspirational home tours, personalised colour consultations and online courses, Emma's ultimate goal is to motivate and inspire people to infuse their lives with joy and happiness through colour.

homemilk.co.uk

Neil Perry is a commercial photographer of design, architecture and the built environment. His honest, unfussy style has helped a diverse range of clients tell the story of their projects for the past 10 years, and his work reflects his love of bold and graphic forms. In addition to his commercial work, Neil is the owner and founder of She Builds UK, a start-up that aims to address the lack of gender diversity in the UK's construction industry. Neil lives in London with his wife and two children.

neilperryphoto.com

Hoxton Mini Press is a small publisher, based in east London. It is run by a handful of book-mad people and a dog called Bug (who hates books, art and interiors). The company started when Ann and Martin met walking their dogs in Hoxton Square, and then went on to get married and start a publishing company inspired by east London and all its creativity and history. They believe that books, and the stories within them, should be cherished.

hoxtonminipress.com

Contents

Emma Merry in her colourful home

Calling the
Colour Curious

I've always been drawn to big, bright, bold colours. I assumed
that everyone was, but over the years I've realised that colour is
unique to each individual. You'll be drawn to different colours
than me, and they will lead you to a palette that can bring
emotional depth and dimension to your world. I want to moti-
vate people to find the colours that spark happiness, lift them
up, and calm them down, and for us all to recognise the power
of colour and harness it within our homes to improve our well
being. This book is a call to arms to anyone who is a little colour
curious and not sure where to start, to tell you to stop sitting and
settling, but to grow into the fullest and most colourful expres-
sion of yourself.

My journey into colour consultation wasn't a typical one.
I started out in TV, moved into advertising, and then into creative
production. But I was always unfulfilled and knew I wasn't on
the right path, and even though I had been trained in interior
design, it took a long time to gather the courage to begin
practicing. So, I started with what I knew: being a nosy neigh-
bour (apologies for peeking into your living room as I pass by).
Plus, I happened to live in an incredibly creative neighbourhood
in Walthamstow, east London, where there were colourful
homes aplenty. An idea was born – I would begin by focusing
on doing home tours on Instagram, showcasing the people and
designs behind closed doors. I named my brand Home Milk.

The home tours became the backbone of the business, and I
posted a new home every week for the first two years while
juggling colour consultations and design projects. I now post
less often as the services side of Home Milk has grown, but the
homes I do post are always magnificent – especially since I was
joined by photographer Neil Perry, with whom I've now done
half of what amounts to around 100 shoots, and who photo-
graphed all of the homes in this book. I love to look back over all

the different homes, and the focus has always been the incredible people who live in them. I'm keen to show that you don't have to be an interior designer to have a really creative home. When I launched the business I also felt that there wasn't an inspirational interiors brand or magazine that truly felt accessible, from the tone of voice through to the furniture and accessories on display; everything felt a bit too fancy, and very white and beige. I wanted Home Milk to be a refreshing change, open to all, an encouraging community of colour enthusiasts motivating each other to bring joy into their homes without having to spend a fortune. And that's the beauty of colour – paint is one of the most cost-effective ways to make a big impact in your home.

There has been a shift away from white and grey walls to more vivid colours in recent years. During turbulent times we crave upbeat and optimistic shades, as well as colours that nurture and ground us. People are realising that colour has the ability to inject life, energy and character into their living spaces; whether it's an eye-catching feature wall, a colour blocking masterpiece, or just a bright pop on a door frame, colourful interiors are back. In this book, you will discover a carefully curated collection of homes that demonstrate many different styles and palettes, all intended to ignite your imagination. I hope that, by inspiring one another, we can become more active participants in the world of colour, cultivate a heightened awareness of its impact, and be unafraid to experiment and paint those walls!

Emma Merry, London, 2023

A peek through the keyhole into *my* colourful home (not featured in the book), to show that I don't just talk about colour, I really love to use it.

Why Colour Matters

Yes, colour matters – but we shouldn't take choosing colours too seriously. It should be a joyful adventure, an exploration of our identities and a fun journey. Colour has the power to open our eyes and encourage us to think about how we want to feel and how we wish to be perceived. By entering the playful realm of colour, you will embark on a voyage of self-discovery.

There's some beautiful science behind how colour connects with our emotions in the fascinating field of colour psychology. Colours have a remarkable ability to evoke particular emotional responses due to the way they interact with our brains and sensory systems. Warm colours like red and orange can elicit feelings of energy, passion and excitement, while cooler hues such as blue and green tend to evoke calmness, relaxation, and a sense of harmony. Certain colours also have cultural and personal associations that contribute to their emotional impact. For example, red may symbolise love in one culture, while it may mean danger in another. Applied colour psychology reveals the intricate ways in which colours affect our mood, behaviour and overall wellbeing, offering insights into how we can harness colour to create desired emotional experiences in our daily lives. While a full discussion of this subject is beyond the scope of this book, Karen Haller is an expert in the field and a good place to start if you'd like to know more about colour psychology.

Each of us processes colour uniquely as our brains differ in how they absorb and interpret colour wavelengths. It's only natural, then, that our preferences for paint colours won't align. And that's liberating, isn't it? We can embrace and accept that not everyone will resonate with our chosen colour palette, so instead of worrying about external validation, or whether our homes conform to current trends, we can confidently step into our authentic selves and discover the true joy of creating a space that reflects our personal style.

Barbara's mood-enhancing scheme (above and p.196) juxtaposes feelgood colours. Jude (right and p.114) embraces deep heritage hues for a dramatic, opulent space.

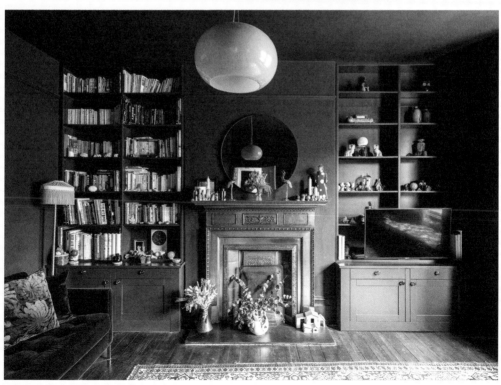

Before You Begin

A great starting point is to approach choosing a palette for your home as if you were your own client. When I do a colour consultation, it's absolutely not about forcing my own preferences on a client. Instead, I make an effort to really get to know them, delving into what they want from their space, but most importantly understanding their unique personality. If a home's colour palette fails to reflect their individuality, it becomes merely a display space, lacking any emotional connection. Whether they are a fun-loving Frank or a sophisticated Susan, focusing the colour choices around their personalities ensures that the space becomes a genuine reflection of who they are and creates deep emotional resonance. So before you begin putting paint on walls, really think about who you are, what are your personality traits, and how others might describe you.

People often dive straight in to selecting colours before they have considered the crucial question, 'How do I want to feel in this space?' It seems like a simple question, but it's a valuable guiding principle, especially when considered alongside 'What will happen in this space?' Step back and think about your home as a whole, then move through each room individually. The answers to these questions will become a powerful tool, as the next step is for you to riffle through your inspiration boards and connect with the colours that resonate with your answers. For example, 'I want to feel soothed in this space and will use it for reading, sleeping and some gentle stretching in the morning', may lead you towards soft pinks paired with mid-tone earthy hues; or 'I want to feel energised in this room, I will use it for dancing and drinking lychee martinis', might lead you in the direction of magenta and emerald green, but again this will be unique to you.

It's also important to evaluate existing design elements, including furniture, architectural features and overall layout

(light is also crucial, which I discuss separately on p.16). This assessment helps in identifying colour opportunities and potential challenges. Are there elements you want to showcase? What are your desired focal points? Perhaps you are delighted with your new DIY wood panelling and want it to be noticed. Maybe you have some really beautiful architectural features that deserve to be seen, or some you'd rather hide – like an ugly old radiator that needs to fade into the background. Once you have identified these elements you will be better equipped to make final colour choices.

When Rob (above and p.32) asked himself what he wanted to achieve, he found that his answer was 'to do something strong', and tap into the healing power of bold colours.

Find Your Inspiration

It is often said that it takes 21 days to establish a habit, so try to dedicate a few moments each day to consciously observe the colours around you until it becomes second nature. Even if you see just one sensational hue during your daily rambles, take a moment to pause and really appreciate it. By adopting mindful observation you will gradually enhance your awareness of colours and develop a deeper understanding of those that truly resonate with you.

The beauty of colour inspiration is that it can be found everywhere, not only in obvious sources such as interior design magazines and Pinterest boards, but also in less apparent places, like the ochre of your dog's fur, your bubblegum-pink shampoo bottle, or a retro 1980s pattern. And don't forget the awe-inspiring wonder of nature's palette, with its harmonious colour combinations. You must be awake to the inspiration around you if you are to connect with your inner colour animal.

Lindsey's quirky Margate home (opposite and p.130) is inspired by her fashion background and the seaside colours of her home town. Hannah is influenced by modern art and Brutalist architecture (left and p.74).

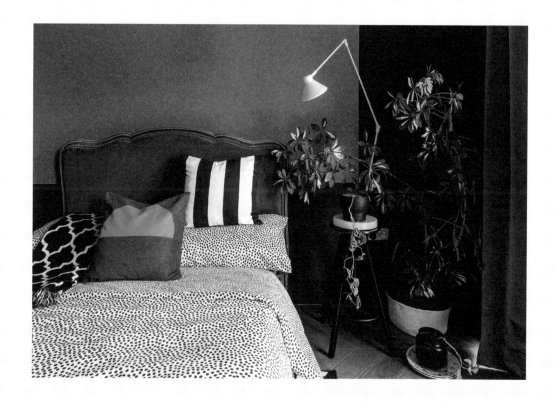

Keep a log

There are lots of ways to keep track of the colours that give you good vibrations: taking photos, clicking 'save' on Instagram, creating a Pinterest board, and even going old-school and cutting images out from magazines. Once you've built up a good-sized collection it's time to review and evaluate, which sounds a bit formal but is really just a lovely peruse through your findings. Which colours are you seeing the most of? You will likely find lots of repeating colours, and these represent your core style. There might be some colours that are seen less often but seem to pop out from the rest, and it's possible that you enjoy these colours but they aren't part of your core style – they are colours that might play a less prominent or more transient role in your home design. But it's important to play around, try introducing them as an accent, and you may find over time you want them to play a bigger part in your scheme as your tastes evolve.

What's your story?

Storytelling can be a powerful tool that can enhance the experience and impact of interior design. It goes beyond aesthetics and creates a space that feels authentic and representative of who you are. A story is a compelling emotional journey that allows you to express your unique personality, experiences, and interests through your home's design. If you look at Jess's home (p.234) you will see how she has used memorable moments from her life to create a home that not only looks incredible but also means something to her and her husband on a deeper level.

Looking to your personal experiences also provides a clearly defined route through the colour chaos that is out there: it's much easier to navigate the huge array of choices when you have a clear story to guide you. If your story revolves around nature and the outdoors, incorporating earthy tones and organic greens establishes a coherent and harmonious design throughout your home. It might also inspire you to experiment with new colours, encouraging more innovative and exciting outcomes – that 'Barbie Dream House' theme could become your reality!

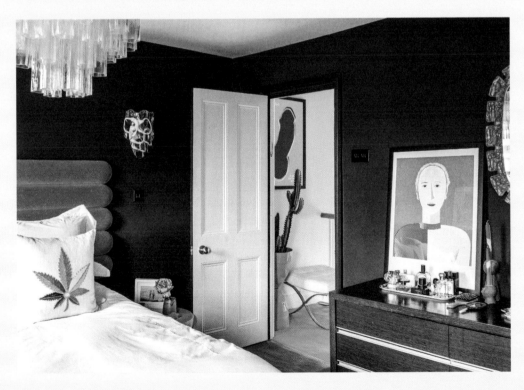

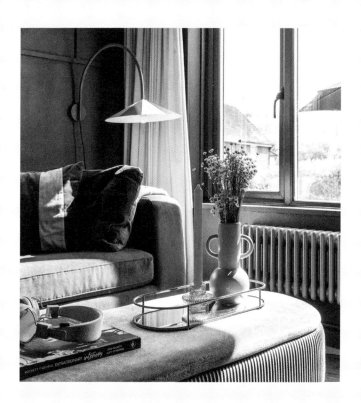

Build around existing elements

Perhaps you already have a large bright orange sofa that, for whatever reason, is impossible to change. How do you work around it? Well, chances are you chose that colour because you love it, as people tend to spend a lot of time considering a big-ticket item like that, so feel happy that it's a colour you already vibe with. Then check back in with what feeling you are trying to create; do you want it to be toned down? If so, pair with softer colours – orange harmonises well with calming blues, greens or lilacs. Or if you want to keep the energy levels up then consider the colour intensity, and pair it with a similarly saturated colour.

If there's a prominent artwork or fabric in your room, this can be an excellent starting point for your colour scheme (see Natalie's lounge on p.30). You've likely been drawn to it because of the way the colours interact, making it a valuable reference for selecting your palette. By leveraging this existing element, you can fast-track your colour choices. Begin by identifying a hero colour from the artwork or fabric as the primary colour for your room, then choose two accent colours from it.

Zoe (opposite and p.174) half-jokingly assigns her home the personality of 'a drunk aunty at a wedding' – with pops of electric brights bringing a fun dimension to sophisticated core colours. Barbara's south-facing snug (above and p.196) uses accents of lilac and pink to uplift the blue-grey sofa and deep purple walls.

15

Respect the Light

The influence of light on colour should never be underestimated. Light can completely transform the appearance of a colour and impact the overall mood of a space. Managing the effects of light can be straightforward when you have the right information, and understanding the direction your room faces is critical when it comes to choosing colours.

Rooms facing south make colour selection relatively easier, as they benefit from sunlight throughout the day. Colours in these rooms often take on a yellowish hue, and you will need to decide whether to roll with this warmth or counterbalance it in some way. If you're considering a neutral scheme and you want to cool off the heat, whites with a hint of grey in a south-facing room may appear warmer than expected. But if you want to ramp up the heat, then yellow or red-based whites will give you a creamy cosiness. For bold and energetic impact, incorporating vibrant, warm tones will radiate energy and make a striking statement.

North-facing rooms make colours feel cooler. People often jump to white in an attempt to add brightness, but it can fall flat in low-lit spaces. If you want to go with white, then choose one with a red or yellow base as this can counteract the coolness. My advice is to stay away from greys and push yourself to be a little bolder, crank up the saturation, and enjoy playing with bigger, juicer colours. Your north-facing room will thank you.

West-facing rooms can be very changeable, starting off the day cooler then warming up in the afternoon (a bit like me). Consider what time of day you use this room the most and lean into that. Embracing the warm afternoon glow is always a good idea, so red-based undertones will give good vibrations to the room.

East-facing rooms present the opposite conundrum, basking in the morning sun and gradually cooling off towards the evening. Consider opting for colours that embrace both aspects of the light.

A punch of saturated blue or green can create an invigorating atmosphere in the morning, with a serene and calming ambiance as the sun sets. It's worth noting that while a pale neutral shade may appear charming in the morning light, it can lose its impact and feel lacklustre for the remainder of the day.

Don't forget to also consider artificial lighting, as this is a crucial element that can elevate your design scheme. But not all bulbs are created equal: cool bulbs are the culprits behind the chilly, bluish light that can make your colours feel frosty. On the other hand, warm bulbs are all about a cosy amber glow. I like to strike a balance and go for something in the middle, allowing the colours to sing, but for snug nooks and crannies I dial up the warmth with lamps and let the bulbs work their magic. It's all about finding the perfect balance between illumination and ambiance.

Jess (above and p.234) blocks out the chatter of trends and focuses on the light in each room and the emotion she wishes to evoke.

Ways of Using Colour

It's not just about the colours you use in your home, it's also about how you use them, and in what proportions. For example, red is a strong colour, but it will be perceived very differently if you are using it in small amounts as an accent colour than it will if you are using it on all walls as well as the ceiling in a fully colour drenched room. It's not just about painting walls, either – the colours you use on your ceiling and woodwork can also make a huge difference to a scheme, and the days of routinely painting ceilings, skirting boards and doors white are long gone. The following are just a few exciting creative approaches with colour for you to consider.

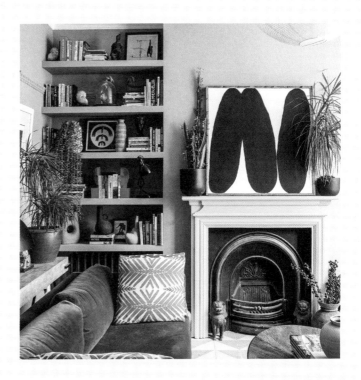

Monochrome

A monochrome colour scheme revolves around the use of a single colour or variations of a single hue, and can create a harmonious and modern look. This design approach often results in a sleek, sophisticated and minimalist aesthetic, where the focus is on the interplay of textures, materials and lighting to add visual interest to the limited palette. Some people can panic at the thought of going so 'big' with one colour and using it for everything, but I believe it adds an air of calm and simplicity. It produces a scheme that does not feel overly fussy, just confident and considered.

Colour pops

Adding a flash of colour to an element of your space – such as the recess of a window, or painting a fireplace or cupboard – immediately adds character. There's something about the colour pop that says, 'I have a sense of humour', without it veering too far into the realms of the wacky. It gives a feeling that all elements of the room have been carefully thought out, and is also a simple first step for those who want to experiment with bolder colour in a smaller way before committing to a full wall. Just try it – I promise you will immediately feel its joy.

Gwen and Patricia (opposite and p.212) stepped out of their comfort zone to experiment with dramatic colour-drenched spaces. Trish (above and p.150) uses judicious pops of bold colour to great effect against earthy tones.

Colour blocking

This refers to the decorating technique of using large, distinct blocks of colour to create visually striking areas or elements within a space. It involves selecting complementary colours and applying them in solid, clearly defined sections for maximum contrast. This is a really fun way to play with colour in your home and can add a sense of drama, be used to blur a room's fixed edges using colour deception to play with focal points and scale, or it can be used to clearly define a room's edge, crafting distinct zones within a space. You can see a perfect example of this in Rob's home (p.32).

Woodwork

Often overlooked until the final stages, woodwork plays a vital role in your colour decisions. Have a look around your room; what opportunities do you have? Is there skirting, cornicing, picture rails? If you'd rather not draw attention to them then go for all-over colour drenching using the same paint colour as on your walls. However, if you'd like to make a feature of the woodwork – perhaps you have some fancy architectural features that you want to showcase – then opt for a contrasting colour. Features can also be emphasised by dialling up the contrast between wall colour and woodwork. Now, should you go lighter or darker? Lighter woodwork will create a sense of openness and airiness, and darker tones produce a more dramatic look.

The fifth wall

Yes, it's the ceiling. I know, no one wants to get on a ladder with a paint brush for some back-bending work (and it is best done on a pre-hair-wash day), but how you approach the ceiling can make all the difference to your room. Whether you go for light and uplifting or deeper and cocooning is totally up to you, and again you should go back to the feeling you want to create. Bringing the ceiling colour down the walls can add the illusion of extra height – see Carol's magnificent lounge (p.90), where she's painted down to picture rail height; the contrasting pink completely uplifts the room. Or follow Emma and Simon's example (p.66) and opt for a darker ceiling with lighter walls for a more enclosed, cosy feel.

Rob's home (above and p.32) is a masterclass in colour blocking, and uses 32 shades. The ceiling in Gwen and Patricia's bedroom (below and p.212) is painted a restful blue, which extends down the top of the walls to draw the room in for a cosy feel.

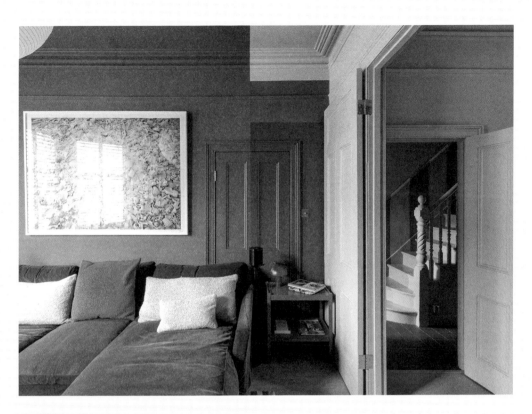

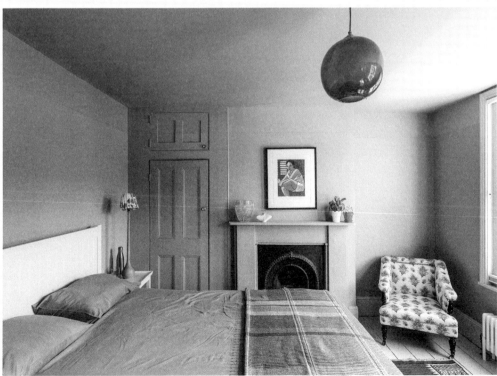

The
Homes

Natalie

Soft, warm tones alternate
with intense, deep colours to create
different moods within the home

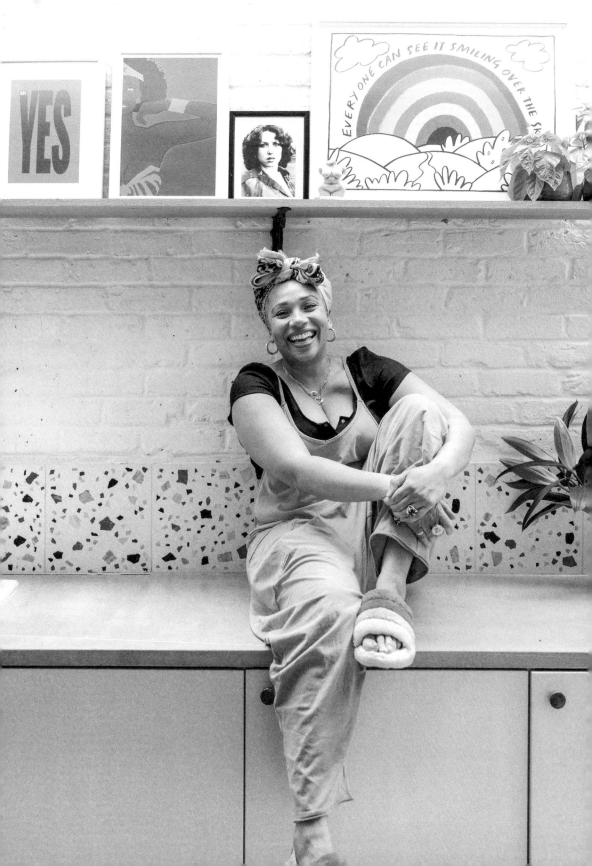

Natalie Lee wears many hats in life: she's an author, course creator, content producer and devoted mother. Her kids may voice their opinions on the colours used in their home, but she laughingly admits that 'They often try to talk me out of things, so I ignore them.' Her approach to making bold colour choices stems from her insistence that it's just paint, and can easily be changed if she ever wants a different feel. Natalie's definition of home transcends material possessions, and she believes that 'having good people around you makes you feel at home, it's not about owning things.' For her, interior design is focused on supporting emotional wellbeing.

Natalie's favourite spot is her 'Palm Springs vibes' kitchen extension: 'It's big and airy, and the feeling of space makes me feel less pressured', she says. 'It allows my brain to breathe.' There's a real sense of optimism about this room, with its uplifting art and soft pastels, and the sunshine yellow of the ceiling beams brings a flash of energy to the tranquil space. Natalie believes that 'Art is the icing on the cake. The thing that gives a home personality and intrigue.' Indeed, she based the entire colour scheme of her lounge around a prized piece.

Reflecting on the origins of her colour confidence, Natalie remembers her mother always encouraging her to be fearless in her choices: 'When I was a teenager, mum encouraged me to get a jacket that was quite "out there", African print, really colourful', she recalls. 'I loved it so much, but it was unlike anything my peers would have worn. It gave me the inspiration to be brave and not follow the crowd.' This individualistic spirit is in evidence throughout her home, from the vivid green lounge with its leopard print sofa to the huge 1970s-inspired stripes in the bedroom.

The peach-toned living room gives a feel of being gently cocooned, before passing through an electric pink archway into the darker lounge. Extending the colour above the picture rail gives an impression of greater height.

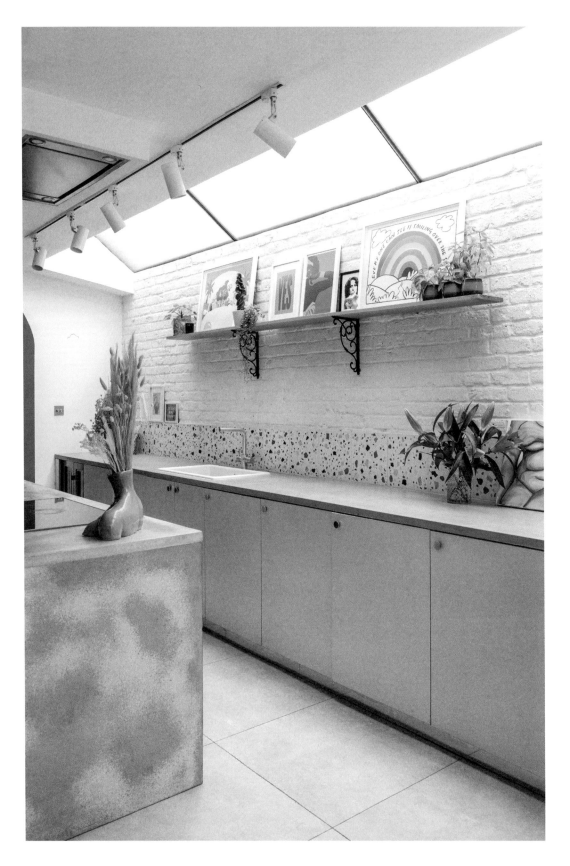

'Art is the icing on the cake. The thing that gives a home personality and intrigue'

(Opposite) The kitchen is an uplifting space, with pops of art bringing a jolt of energy to the pastel palette. The scheme was designed to evoke a Palm Springs vibe.

(This page) The retro blend also appears upstairs in the bedroom, with ceiling and walls embellished with a huge 1970s stripe, pulling together the other elements.

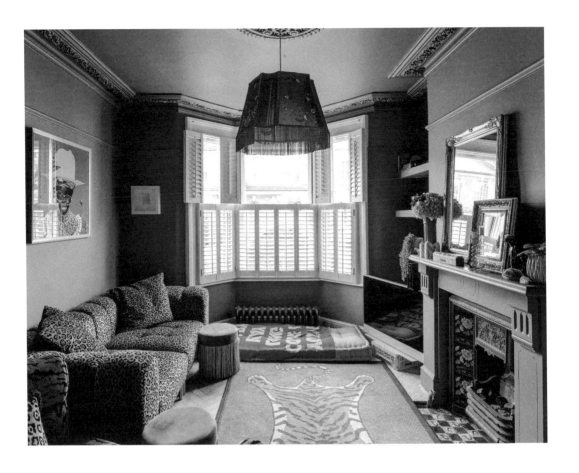

Chosen because it signifies renewal and love, the vivid green of the lounge is picked out from the artwork on the wall, the depth of colour working well in lower lit areas of the home. Pairing it with a retro leopard print sofa gives it a glamorous edge, and the pink archway adds a quirky sense of fun.

Rob

An uplifting journey, where a project born in tragedy became a colourful celebration of life

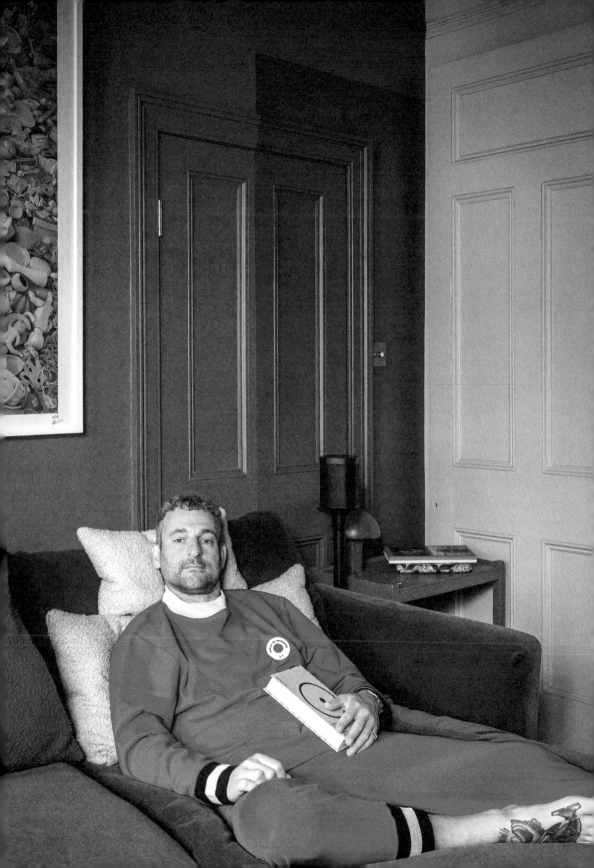

The renovation of this home was an emotional project for owner Rob Rafalat. The house previously belonged to a Cypriot grandmother, and felt stuck in a 1950s time warp. He initially shared it with his late sister Zu, and when they first moved in she led the design and bold colour wasn't on the cards. But living in it alone and grieving through lockdowns at the height of the pandemic, he made a decision that would help him recover from her loss and demonstrate the healing power of colour: 'I decided I *needed* to change it all. Completely. I wanted to use primary colours – reds, yellows, blues – and had dozens and dozens of very different versions of what it could look like.'

Rob enlisted the help of Zu's great friend, designer Rhonda Drakeford, who was able to bring a little calm to temper his bold plans, adding in neutrals and textures for balance. And so began a process that would transform the house with magnificent bursts of colour (32 in total). Rob's explosive vision found balance, harmony and a touch of the unexpected.

For Rob, creating a home with a sense of drama felt intertwined with who he is and what he does. 'I wanted to do something strong', he explains. 'As a filmmaker, I make and like things that are fast and strong and bright and punch you in the face.' The result is a home that feels futuristic and subversive, and above all demonstrates his fearless approach to colour and design. It's somewhere that Rob feels emotionally connected to, but it also feels like it has a life of its own; Rob says, 'It feels like its own thing, like "where the hell did this come from?" And I love that.' The beautiful collaboration between Rob and Rhonda during such an emotional time has resulted in unexpected colour choices that speak to both spiritual nurture and a true celebration of life and vitality.

(Previous page) The design jigsaws together multiple blocks of colour, but feels considered and balanced.

(Opposite) The use of raw plaster gives contrast, texture and added dimension to the flatter blocks of bold colour. Here the authenticity of the raw material is punctured by bolts of citrus yellow.

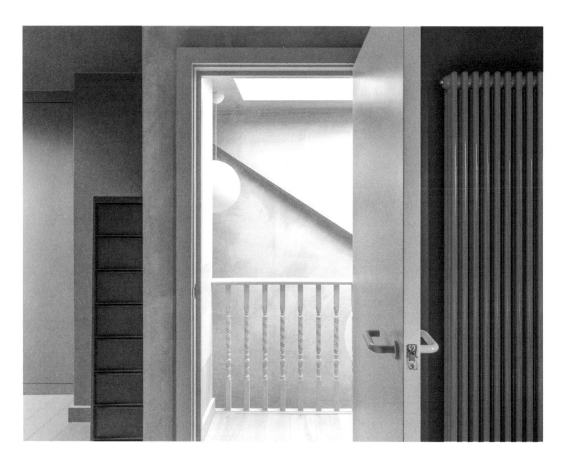

'I wanted to do something strong. As a filmmaker, I make and like things that are fast and strong and bright and punch you in the face'

The overall palette includes 32 colours in total, ranging from pure, bold hues to earthy tones and neutrals. It's a masterpiece of the unexpected, where the contrasts make the bright colours seem brighter without being overwhelming.

(This page) The design doesn't follow the normal lines of a home; wall colours don't finish at skirting boards and end at the ceiling, they play with the dimensions of the space. Colour spills from bannisters onto floorboards, and paint that unusually begins a little below the picture rail flows up and onto the ceiling.

(Opposite) The bold primaries bring the fireworks, while caramel and off-white tones add balance and elevate the overall colour scheme.

Anna
& Denis

Modern meets heritage as bursts
of colour uplift a sophisticated scheme
in a Victorian family home

Anna and Denis Wray transformed their mid-terrace Victorian townhouse from a space that felt cosy but a little too enclosed into a light-filled home with fun colour accents. Anna teaches art and textiles, and wanted to use her artistry to create a home that would work for them and their two children. The scheme consists mainly of mid to deeper tones but is balanced with neutrals and an occasional pop of colour, so it feels cohesive but still interestingly varied.

The pair were keen to keep some contrast between the old Victorian areas of the house and the newer extensions, with Anna saying, 'We love the pops of brights against dark and muted tones in the original parts of the house, with warm, pale tones in the modern additions.' For the entrance hall they favoured deep green for its classic look and sense of calm, and this gives way to a lighter mint tone that continues to the top of the house, where light flooding in from the skylight transforms it into a bright and uplifting hue.

The downstairs is all open plan, so you move from the airy kitchen-diner through the mid-green playroom and into the lounge, which is painted a restful peachy terracotta. The lounge had always been a difficult room to decorate as it is north-facing and overshadowed by trees, so it can feel quite cold and a saturated paint colour was crucial. Bright and welcoming during the day, the walls take on a softer hue under lamplight in the evening. The playroom connects the two areas and is lifted with cheery splashes of yellow to boost creativity, and this feeling of moving from an active space into a relaxing one is clearly defined through colour.

Layering different tones of similar colours – the pale walls, pinky warmth of the timber and deeper terracotta light fittings – gives a unified, considered look to the kitchen, creating a calm backdrop for this busy zone of the home.

(This page) Soft pink and mint green are used on kitchen walls and doors, and repeated in accents and accessories.

(Opposite page) Acid yellow adds a pop of colour to the piano room and prevents the scheme from feeling too heritage. Here, green works almost as a neutral, allowing books and art to take centre stage.

'We love the pops of brights against dark and muted tones in the original parts of the house, with warm, pale tones in the modern additions'

(Opposite and over the page) The north-facing lounge has been brightened with peach walls, which help maximise the light. In the evening, dark velvet curtains are drawn to create a cosy enclosed space, and the walls take on a warm glow under lamplight.

(This page) The zingy rail gives a modern twist to the banister and is a vivid thread leading upwards through the house.

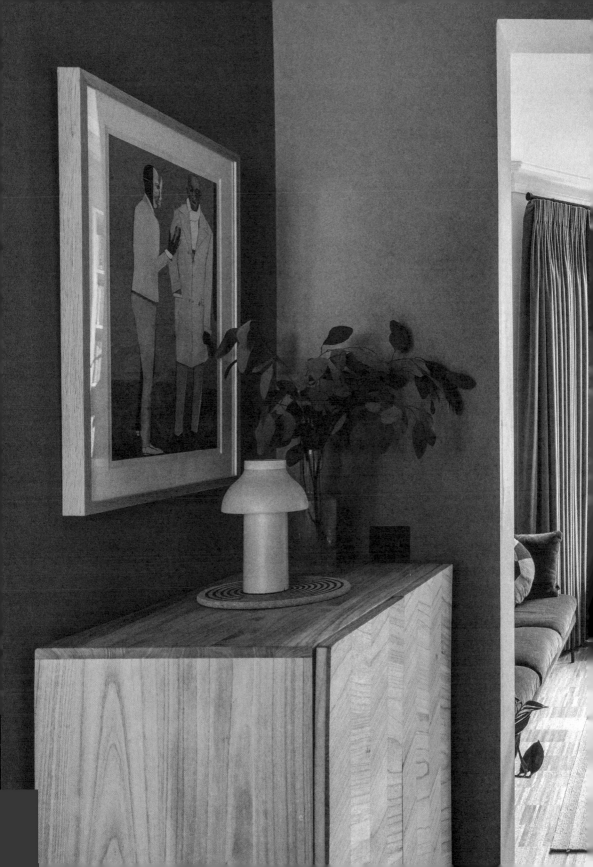

Nat & Kat

Clashing combinations and creative
colour blocking supercharge the home
of these movie costume designers

Nat Turner and Kat Borošová have both worked in costume design for film and TV, and the experience of playing with colour and texture as well as imagining how each item works as part of a larger scene was invaluable when it came to designing their home. 'It's just like designing costumes – they have to tell a story, and here each room tells its own story', says Kat.

Nat took the lead with colour decisions as Kat admits her natural inclination is to paint everything white, whereas he sees their home as a place to experiment: 'I don't really care what people say about it, it's our house and if it's terrible, just paint over it', he says. 'It's more fun to think for yourself and try to create something of your own.' Around every corner there's an exciting new colour combination, which plays out not only within the rooms but also between them. A neon pink stripe marks the division between the cosy, enclosed lounge and the light-filled sitting room and is a lively contrast with the dark walls, bringing a jolt of excitement.

The kids' bedroom is proof that creativity can come from anywhere – the dominant yellow was inspired by the children's hair colour. Their daughter insisted that one wall was a map so she could see where Nagymama and Nagypapa live, and Nat was able to find one in a vintage style that perfectly matched the room's colour scheme. Integrating elements that have personal meaning can be a catalyst for creativity.

This home will never be static as Nat and Kat's style changes with exposure to different cultures and art through their travels. Evolution is part of this home's narrative, ebbing and flowing with the family's colourful life, and it will forever be a place for experimentation.

Acknowledging that the lounge will remain dimly lit, the decision was made to embrace its subdued character with a deep, cocooning brown. Flashes of bright pink in the sofa fabric pick up the pop of colour at the entrance.

'It's just like designing
costumes – they have to
tell a story, and here each
room tells its own story'

Colour combinations were chosen
to create interesting vistas from room
to room. There's a keen awareness of
how they interconnect, and a fun
paintbox effect is produced by the
rooms that radiate from the
colour-drenched green landing.

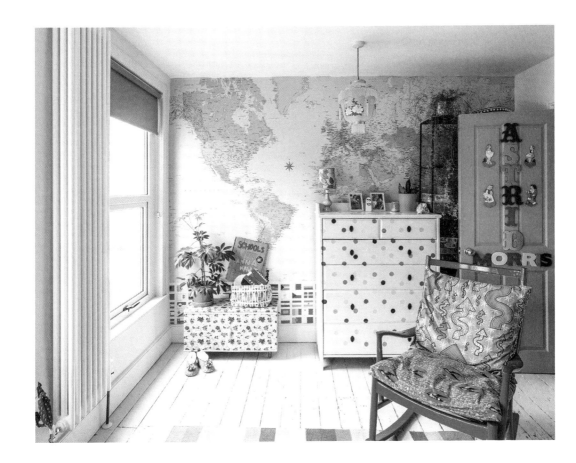

In the kids' room, colours on the walls and door pick out those in the vintage map – a happy accident. To disguise uninteresting window frames, teal and pink blocks were added (and over the page). Using a pop of colour in a window recess is an easy way to experiment with colour on a small scale.

(This page) The seductive deep blue and dark cabinets in the master bed room are enlivened with accessories in bright orange and pink, adding a playful touch.

(Opposite) Keeping things simple is often the key to a small bathroom design. The green grid of tiles echoes the colour of the landing, and pale pink walls give a tranquil feel.

Natasha

Pops of sunshine yellow elevate this
vintage-inspired interior, balanced by
swathes of deep moss green

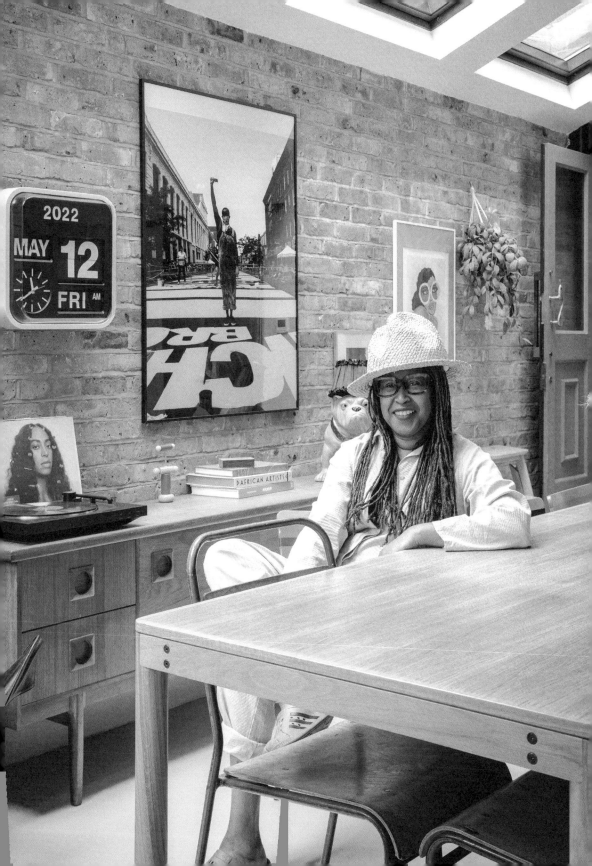

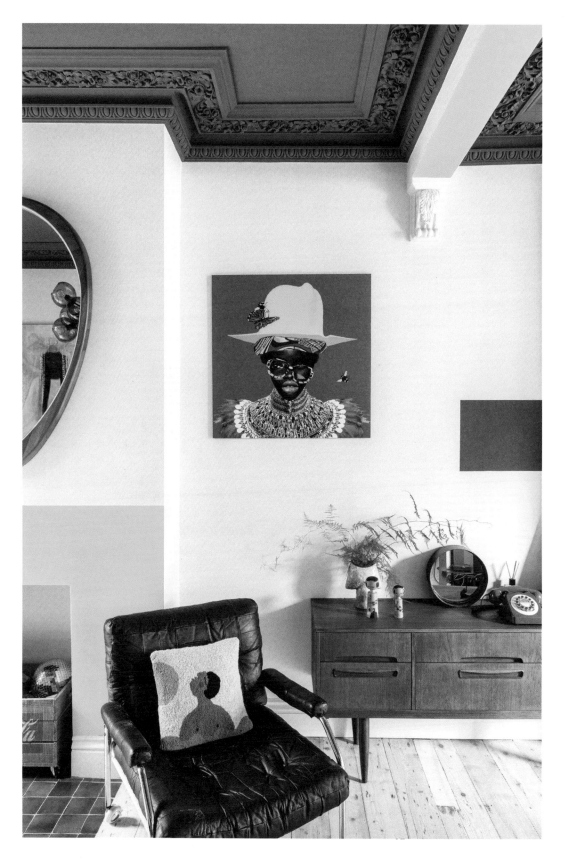

Natasha Landers is a designer and diversity consultant, and she occasionally hires out her striking house to be used as a location for shoots. Her home matches her upbeat spirit, and is filled with lively colour, eclectic furniture, and a fun mix of high-end and high-street design choices. For Natasha, home is a place for entertaining friends, spontaneous kitchen dance parties, and snuggling on the sofa with her daughter and Reggie, their cocka-poo. Her choice of decor is intensely personal: 'My home is an extension of me,' she says, 'I dress like my home, and my home is dressed like me.'

Natasha begins her design process by considering a room's function and lighting conditions, and how different colours may appear under varying light sources. She uses accent colours in the form of rugs, cushions and light fittings, but the walls are the foundation of the scheme. The geometric blocks of colour create a feeling of energy, both defining the space and leading you through the house: yellow encircles the floor and ceiling in the lounge, drawing the eye across the floorboards and up and over the roof beam; yellow and green squares overlap door frames, and rectangles connect the different areas.

This is a home that refuses to take itself too seriously, from the artful colour blocking to the vibrant kitchen floor, and the scheme is dominated by Natasha's favourite hues of green and yellow. She explains that green connects her to nature, and uses it in various tones through the house – from olive in the living room to a brighter green in the hallway and a mossy shade in the bathroom. And the yellow kitchen floor, she says, 'means that no matter how dull the day, the room always feels like sunshine.'

In the living room, the dark olive ceiling gives a sense of drama, and the pristine white walls are a canvas for graphic colour blocking in Natasha's favourite yellow and green – also showcased in the artwork.

'My home is an extension of me. I dress like my home, and my home is dressed like me'

(This page) Moss green gives a grounded, earthy feel to the bathroom, enhanced by plants and natural materials such as rattan.

(Opposite) The kitchen features a lighting installation crafted from copper pipes, loosely inspired by the London Tube map. Unexpected materials and creative designs add a unique charm – the vibrant rubber floor brings perpetual sunshine, and the barn door adds rawness as an interesting contrast to the precision colour blocking.

Emma & Simon

Layers of colour and texture in rich tones creates a characterful and comfortable home

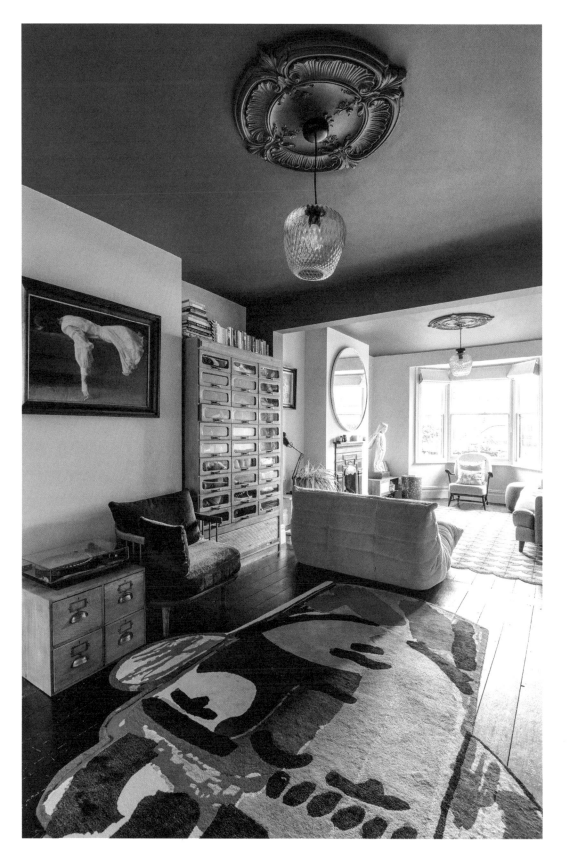

Emma Morley and Simon Goff's home, which they share with daughter Bibi, is a true reflection of their creative imaginations. Both work with colour and pattern professionally – Emma owns an interior design studio and Simon has a rug business – and share a deep appreciation for bold colours and unique design. Emma describes their home as being 'Characterful, colourful, plant-full and welcoming,' with 'fun elements of surprise throughout.'

The couple's colour choices have been inspired by their travels. 'I love to see how colour is used in different countries, in different settings, and in fashion', says Emma. 'We should always be looking outside our immediate world for inspiration.' She likes to choose one or two items, such as a piece of art or a tile, to use as a starting point for a design scheme. Layering is key as it adds depth and interest, and Emma loves to work with contrasts and combinations of vintage and modern elements to create surprises.

Rugs from Simon's collection are glorious bright spots throughout the home, bringing warmth and comfort but also adding personality to the space. In the lounge, the couple show us that the best way to use red is with total confidence. They have flipped the usual practice of having dark walls and a light ceiling by painting the walls in a soft, dusty pink and the ceiling a deep shade of red. People are often afraid to use red, but when paired with a soft tone, like this pink, it feels both cosy and glamorous. From the confident colour blocking to the layers of textures and pattern, every detail in Emma and Simon's home has been carefully considered, and the end result feels timeless.

The living room is anchored by black painted floorboards, with a rug from Simon's collection adding texture and colour. Modern velvet armchairs sit happily beside vintage storage boxes and glass haberdasher's cabinets, blending eras to striking effect.

(Over the page) Ochre tiles give an earthy feel to the kitchen, and dark green concrete worktops provide contrast. Painting the upper walls an off-white helps to create a balance with the deep colours of the units.

69

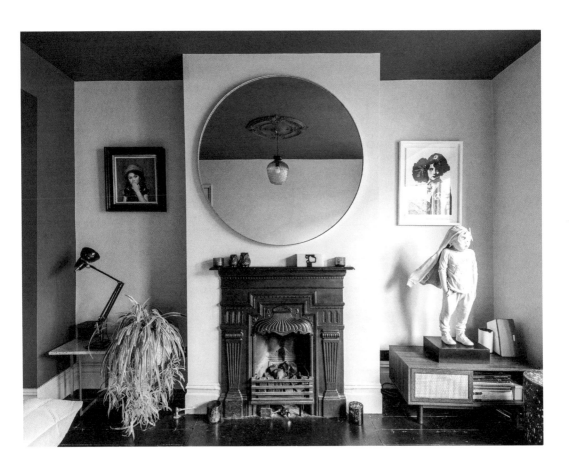

'I love to see how colour is used in different countries, in different settings, and in fashion. We should always be looking outside our immediate world for inspiration'

(This page) Flipping the default choice of white ceiling and coloured walls produces a dramatic effect. Deep red draws the ceiling down, and teamed with warm white gives a cosy vibe without feeling too enclosed.

(Opposite) Mosaic tiles in the shower pick up on favourite tones of teal and ochre, while the walls and ceiling of the bathroom are kept simple in muted pink.

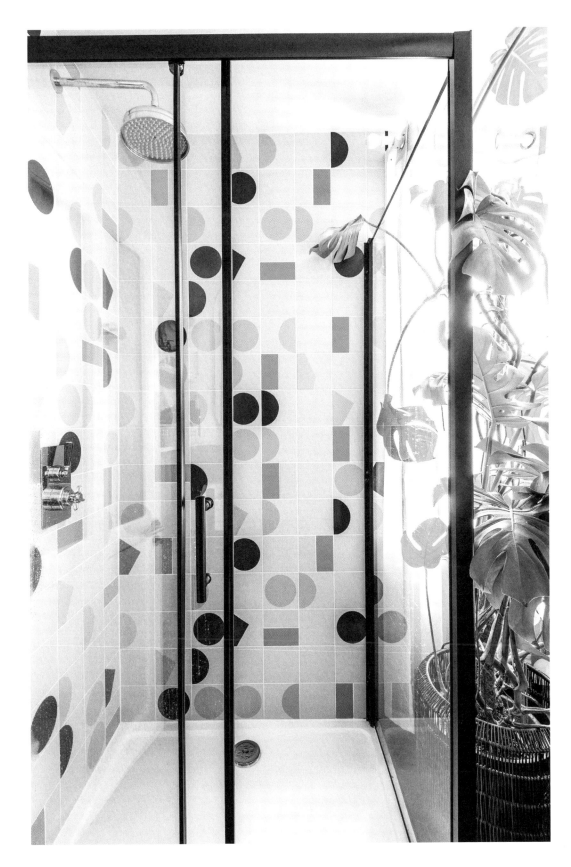

Hannah

Shape-shifting home combines big
geometric patterns and punchy colours
for a high-energy scheme

Hannah Drakeford is the founder of an interiors and homewares design studio, so was keen to transform what she describes as 'a boring beige box, with beige carpets, a beige kitchen, bathroom, everything!' when she moved into her new build. Influenced by mid-century art and Brutalist architecture, her design choices are characterised by graphic black and white patterns and saturated pops of colour, and she's particularly drawn to compositions of brightly coloured geometric shapes. The result is a home that reflects her unique style and shows how a consistent vision can lead to a wonderfully cohesive space.

Colour has a powerful effect on our moods, and for some the use of very strong colours might be overwhelming – but the opposite is true for Hannah. She loves the impact they have on her mood and energy levels, and has 'always believed that colour has a huge impact on our wellbeing. For me, living in a colourful space is incredibly uplifting.'

Hannah is known for her creative DIY projects, with sustainability being a top priority. A great advocate of thrift shopping for the home, she is acutely aware of the damage that fast furniture is doing to our planet. By upcycling existing pieces, she reduces waste and creates one-of-a-kind personalised items that reflect both her style and her values. She explains that she was raised by a strong and independently minded mother and has inherited her resilience and resourcefulness, never being afraid of a challenge, nor of making mistakes along the way: 'I've never lacked the confidence to give things a go, if there's a practical skill I don't have, I always assume I'll figure out how to do it somehow, and that making mistakes and bodging things together is just part of the learning process.'

Hannah often begins with a base of black and white, then layers on punchy accent colours. In the bedroom, dark walls are enlivened with a sunshine yellow graphic, while the ceiling is given a heart-lifting burst of orange.

77

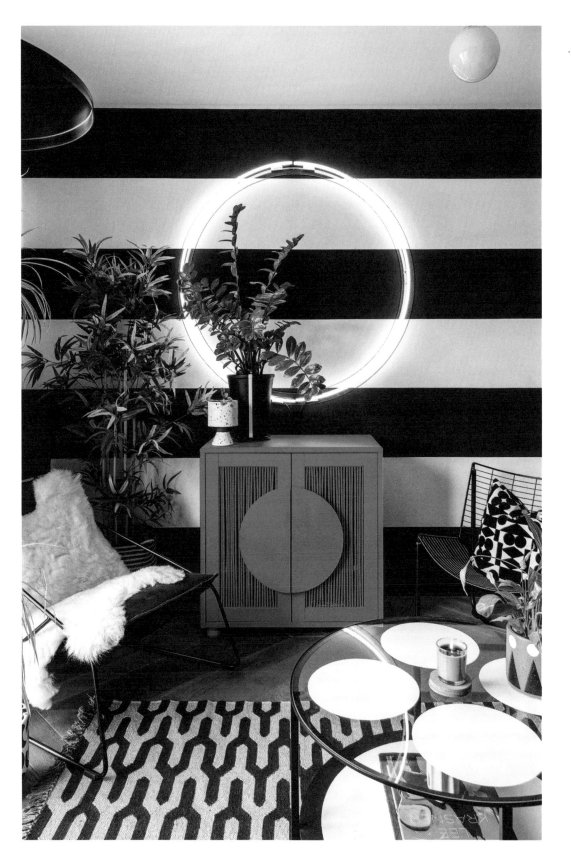

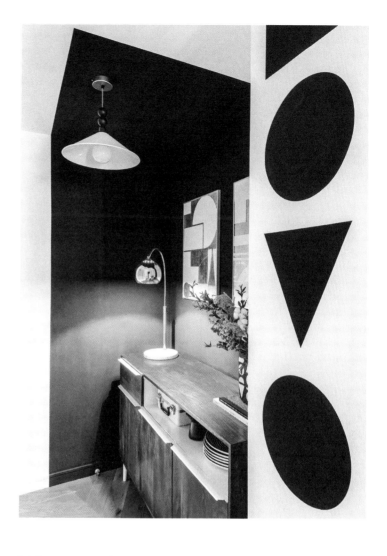

'I have always believed that colour has a huge impact on our wellbeing, and, for me, living in a colourful space is incredibly uplifting'

The red cabinet in the living room is a perfect example of how to use colour to bring a burst of joy. The circle motif is cleverly incorporated in a lighting feature, adding another dimension to the striking black and white striped walls, and is repeated in the handles of the cabinet and graphically on other walls.

Michelle

Subdued colours create the perfect
background for layering print, pattern
and art in a fashion stylist's home

Michelle Kelly, a fashion stylist and interior designer, has created a home that reflects her eclectic sense of style. Her expertise in dressing people extends to her approach to decorating rooms, and she believes that, just as individuals have unique personalities, rooms also have distinct characteristics that call for particular colours and patterns. While she takes the reins in designing her home, she welcomes the input of her husband Iain and their daughter Iris. Iain has a keen eye for unique pieces, often finding treasures on his travels (he recently squeezed a pair of art deco lamps into his suitcase).

There's a sophistication and timeless elegance to this home; the blend of different styles, eras and influences creates a harmonious fusion of old and new. Michelle effortlessly mixes antique furniture with modern accents, juxtaposing bold patterns with muted tones and combining vintage pieces with contemporary artwork. 'I like to mix up eras and go with things that I love', she says. 'I am very drawn to the glamour of art deco, but also like a bit of 1970s rattan, and have always loved a Liberty print.'

Print plays a big part in Michelle's home, and can be seen in the wallpaper, flooring and soft furnishings, and she knows that even the simplest accents, like a striped lamp or a whimsical cushion, can spark happiness. She likes to let colour options sink in for a while before making her final choices, viewing them at different times of the day, and says, 'I like to paint big areas of samples and go back the next day to see it with fresh eyes.' Her clever use of expansive swathes of colour on the walls allows the patterns to take centre stage.

In the living room, the muted wall colour is a backdrop for the vibrant modern art, which sits happily alongside classical details like the elaborate cornices and marble fireplace. Rather than being jarring, out-of-context pieces can make a scheme feel fresh.

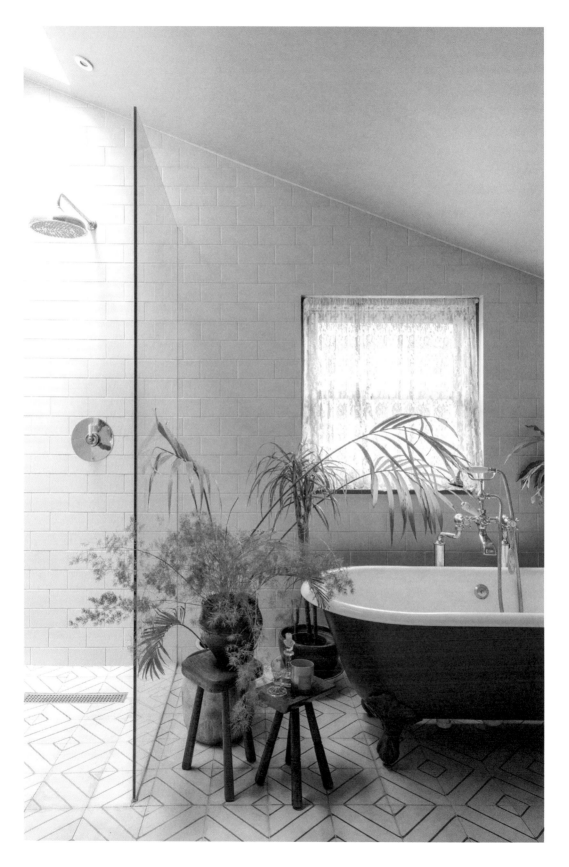

Michelle

The bathroom is a soothing and tranquil space, with walls, woodwork and ceiling wrapped in a bubblegum pink, and mint green tiles and a darker green bathtub providing a tonal change. Palm fronds and ferns add a natural, textural element.

(Over the page) Michelle's daughter's room is full of unexpected elements, such as the wallpapered wardrobe and painted green frame of the sash window. Pattern is a pleasing mix of styles and eras, with vibrant textiles, vintage tiles and delicate florals.

Mixing up accessories creates interest; here, seemingly disparate objects – an art deco brass lamp and vintage vase – are unified in their colours, picked out from the framed fashion illustration.

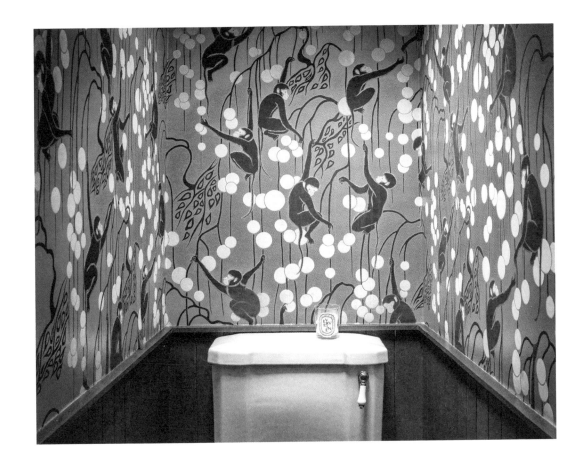

A bold, busy print can be impactful
in a small space. This de Gourney
wallpaper is inspired by 1920s textile
designs, the rich terracotta
enlivening the navy panelling.

Carol

Art-print designer extends her brand
colours of pink and green into the
home for a modern vintage feel

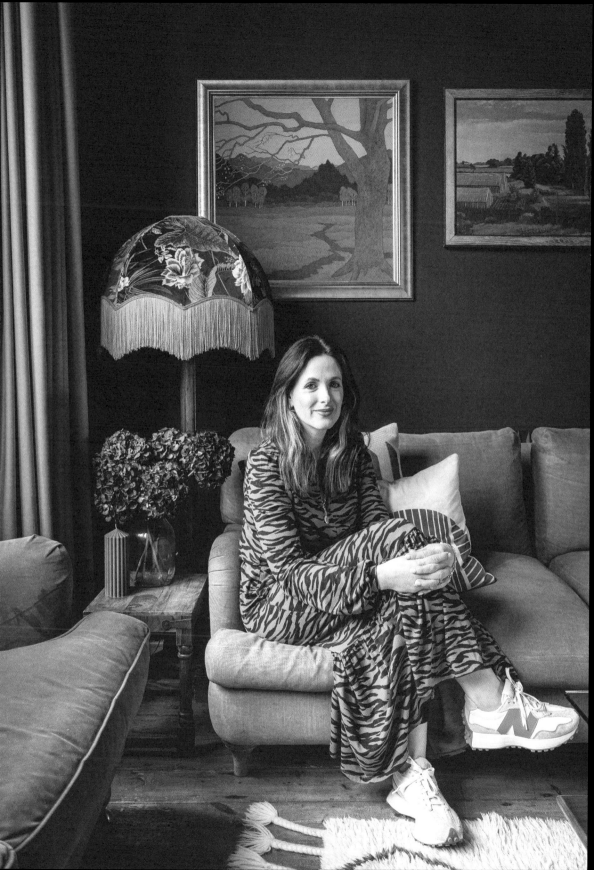

Carol Maxwell's background in textiles and her passion for design have created a home with a unique personality. It was the arrival of her son, Max, that led to the establishment of her own brand, Max Made Me Do It: 'I found myself drawing bits of art for his room', she explains, then she began creating prints for friends, and her business rapidly grew from there. Inspired by her brand colours of pink and green, she decided to incorporate these when renovating her home.

Carol's husband Tom loves antiques, his mother having owned an antiques shop on King's Road, and Carol's expert use of pattern and heritage colours such as moss green and navy-blue work in harmony with this vintage vibe. For a modern twist, she introduces bolder greens and pastel pink. Pattern plays a prominent role, from striking botanical wallpapers to geometric cushions, and it stirs in Carol memories of the rose wallpaper in her childhood bedroom. 'I remember working out the repeat pattern,' she says, 'and I guess that's where my love of pattern started.' It is always used in synergy with the wall colours, and it's often the pattern that inspires the scheme, with the palette being built around it.

In the children's bedrooms, Carol wanted to create environments where Max and Mylo can explore and grow, and which reflect their individuality and inspire their creativity, which she achieved with colourful murals. While unafraid to make brave decisions, she admits that 'The bathroom was a risky move at the time, pink and green hadn't yet exploded as a popular colour combination. It felt risky doing full tiles in pink and green but it's ageing really well, I'm proud of that room.' And in the lounge, the painted ceiling wasn't an easy decision but one she's glad she made: 'It feels enveloping, like a late-night bar or boudoir, it creates a mood.'

Contrasting pastels with heritage colours brings a contemporary shine to the traditional look. Pink and green are used in different tones throughout the home. Here, the palest pink with moss green lends the sunny dining room a rustic chic feel.

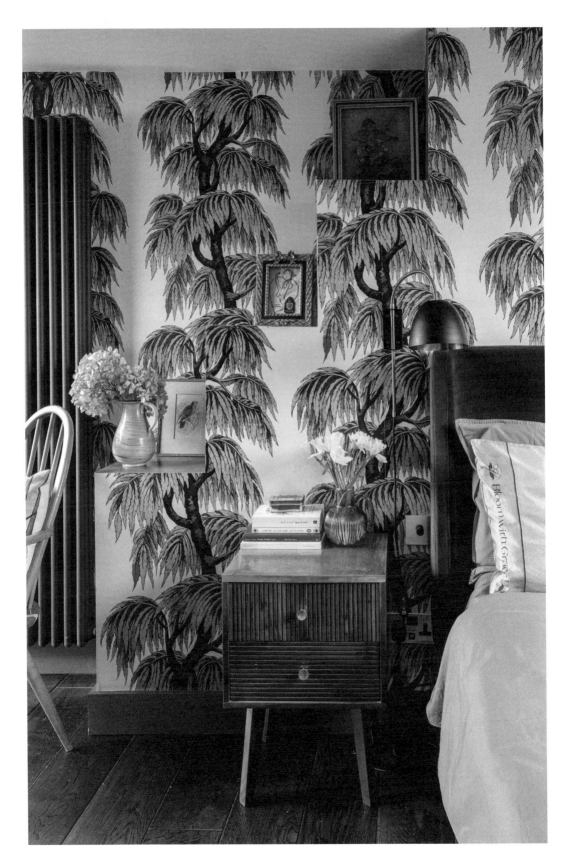

(Opposite) The botanical wallpaper takes centre stage in the bedroom, with texture and interest coming through in the accessories and antique furnishings.

(This page) Painting the fireplace green and using bright accents in accessories is a clever way to bring fun, energising colours into a bedroom without them feeling too much. In the lounge, objects in one colour create a striking arrangement.

(Over the page) The lounge feels cocooning in Hague blue, this classic dark tone complemented with a deep rose-pink ceiling. Velvet and feathery dried grasses together with vintage and modern patterns create the appearance of a sumptuous modern-day parlour.

'The bathroom was a risky move at the time, pink and green hadn't yet exploded as a popular colour combination'

(Opposite) Pink grid tiles and green floor tiles continue the theme in the bathroom, with a decorative plaque from a French church adding an appropriately contemplative touch.

(This page) In the office space, Carol has skilfully colour blocked the ceiling in a refreshing green hue, extending the line across the window frame. This thoughtful detail adds a touch of modernity.

Mariam

Light and bright palette that radiates
warmth and pays cheerful homage
to the heritage of a 1930s house

Mariam Mansoor's 1930s home feels soothing and welcoming, with a nod to art deco style. When renovating the rundown house in London, she wanted to retain its original charm: 'I knew it couldn't compete with neighbouring Victorian properties, so I wanted to create a unique space that celebrated its 1930s bones, with pops of art deco throughout.' The result is a light-filled home where peach and mint green take centre stage, accompanied by the timeless beauty of accents like terrazzo and fluted glass, in keeping with the house's heritage.

Mariam needed to incorporate room to work, but also wanted to create a fun space for her children, Yusuf and Safaa. She has included lots of playful elements, from the green arches in the hallway to the gym wall in the kids' room. This is a home that pulsates with life, and even in the meditative green lounge there is a pop of peach in the office area which brings energy and fuels inspiration when Mariam sits down to work. She says that 'the reflection of the peach arch from my office nook onto the oriel window is actually my favourite part of the house. Every night, when I close the kitchen door and see the reflection, it makes me smile.' It's not only the individual colours that bring joy, but also how they interact with other elements in the home.

The powdery pastels of the loft and kitchen create a serene effect, whereas punches of stronger colour in the kids' rooms and bathroom inject vitality. You will notice a lack of cool hues in this home, as everything was chosen with warmth and cosiness in mind without compromising on style. The energy in Mariam's home shifts as you move room to room, but there's an overall feeling of harmony.

The ensuite bathroom is a mixture of pink, terracotta and green. The pinks of nurture and greens of nature have a grounding and rejuvenating effect. Brass fixtures add shine, while the terrazzo and ribbed glass gives it a modern edge.

(This page, above) In her daughter's room, pale pink wraps all of the walls, and a mossy velvet headboard adds a more sophisticated edge, making it a room she can grow with – but for now the play wall is the focus.

(Left and opposite) As you move through the home, you experience the interplay and balance of colours. From the light pastel kitchen there are sightlines through to the vibrant office nook and into the enveloping darkness of the lounge.

'I wanted to create a unique space that celebrated its 1930s bones with pops of art deco throughout'

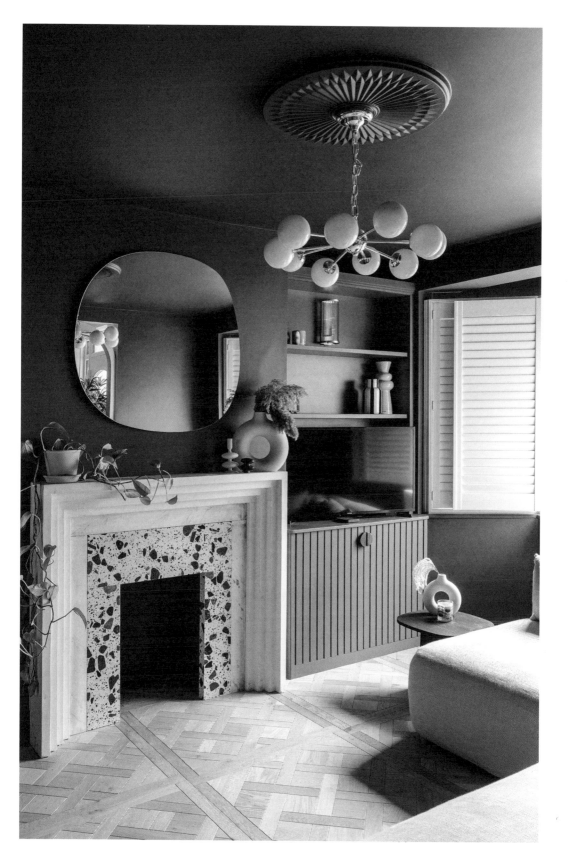

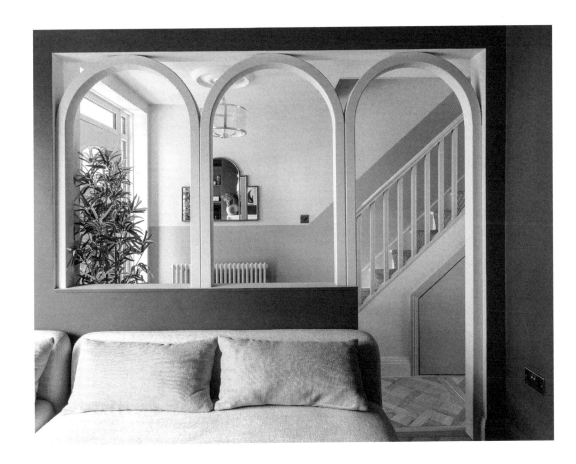

Painting the ceiling the same deep
blue-green as the walls makes the
lounge feel enclosed and comforting,
but light floods in from the hallway
through internal arches so the room is
bright during the day. The colours are
a language, connecting each space
to the next while allowing their
distinct identities to emerge.

Ms Pink
& Mr Black

Acid brights and neon pink
produce an eye-popping display
of punk positivity on a grand scale

In this home, electrifying, brash colour reigns supreme, its owners declaring: 'We've always said if you want a colourful life, you need colour in your life, so that's what we've done. Colour makes us happy, the brighter the better.' Homeware designer Ms Pink, along with her partner Mr Black, a screen print artist, have created a home that epitomises their punk spirit: a place of freedom and authenticity, with a personality that is loud and unapologetically in your face.

Scale plays a significant part in the design, with both colour and pattern generously used in large swathes rather than delicate touches. 'Just be brave – do what you want, it's your home', they insist. 'It's better to be a trendsetter than a trend follower.' Ms Pink's immersion in London's punk scene in the mid-1980s instilled a love of shocking colour, while Mr Black's background in textile design has nurtured his passion for colour and texture. Together, they make fearless choices and their home is a vivid expression of non-conformist glee.

Every inch of space is alive with neon hues, colour blocking, graphic art and oversized patterns and plants. From the well-designed kitchen to the vibrant living room that transforms into a soothing sanctuary at night, their home is a kaleidoscope of joy. Pink and yellow stairs, decorative trays displayed on the wall, a window filled with enormous plants in colourful pots, 1980s ceramic faces, a wild patterned green sofa, a wallpapered living room ceiling, a red and pink striped floor, and an eclectic collection of oversized gummy bears – each element contributes a piece to the sensational whole.

A punk palette of electric neons dominates the home, while typographic prints, eclectic artwork and graphic paint effects contribute to the colourful chaos. But when the lights are low, the lounge becomes a surprisingly cosy and relaxing space.

'We've always said if you want a colourful life, you need colour in your life, so that's what we've done'

(This page) In the kitchen, each cupboard door is painted a block of confident colour, matched in scale by the chunky stripes on the wall and ceiling and the oversized grid tiles on the wall.

(Opposite) Huge plants sit in large colourful pots, bringing a touch of nature to what is otherwise a very digital aesthetic. Oversized gummy bears add to an *Alice in Wonderland* sense of disproportionate scale.

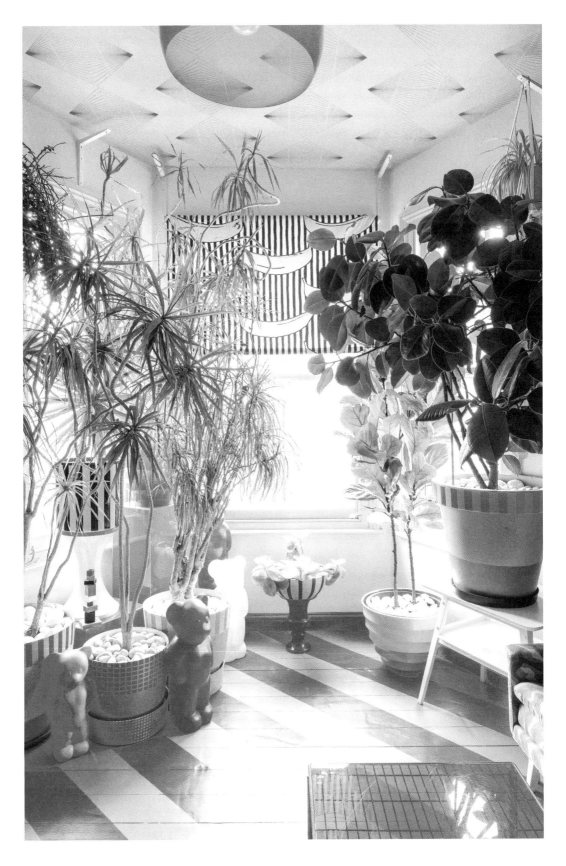

Jude

Opulent jewel tones give way to
candy-coloured pastels to create
a house of many moods

Jude Whyte is a creative director and interiors enthusiast who shares her home with partner Richard, their children, and Betty, a glamorous rag doll cat. The interior is inspired by her love of textiles, fashion and graphic design, and her colour confidence has grown with experience. 'I've realised over time that I don't have to please anyone but my own family in my home', she says. 'I know that my colour choices are polarising, and I'm ok with that!'

Each room brings its own energy: the bathroom is cheerful with its yellow shower tiles and bath, which Jude says 'is like starting your day basking in sunshine'; the dark green walls and deep jewel-coloured furnishings of the lounge make it feel at once dramatic and cosy; the bedroom is calm and relaxed with light pink walls, an unusual teal carpet and wood panelling lending it a mid-century modern feel. Sometimes it pays to have tastes that are a little outside of the norm: Jude's carpet supplier said he couldn't give her any samples to take away, until she explained that it was the teal one she was after, which he said was fine as 'nobody wants that one.'

The unique feel of each room is a result of them being designed individually, rather than creating a scheme for the whole house in one go, and Richard says he enjoys the different personalities of each space. Jude is making her way around the house, embracing new ideas and influences as she goes, but always keeping mood in mind. While she is bold with her decisions – and readily admits that they occasionally backfire – she gives them careful consideration before she begins, collating images on Pinterest, creating mood boards of furniture and materials, and trying out paint samples on the walls.

Mint and lilac in the bedroom, together with a framed retro print, pop of orange and a shaggy sheepskin cushion, give off a cool 1970s vibe. A discreet book nook has been cleverly incorporated into the wall by the bed.

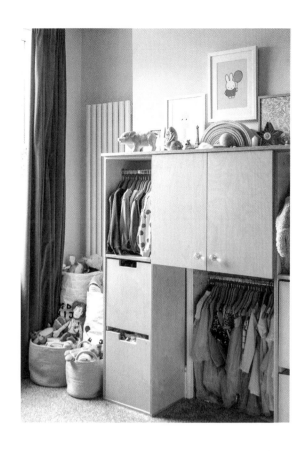

(Opposite) There's a shift of mood in the lounge, where dark walls and sumptuous sofas create an opulent, almost decadent, feel that sets it apart from the rest of the house. It's a dramatic and modern look with heritage features.

(This page) In the kids' room, peachy pink and teal create a backdrop for fun prints and toy stacks. These colours are repeated in the master bedroom, where the teal carpet is perfect as a mid-century modern accompaniment to wood panelling.

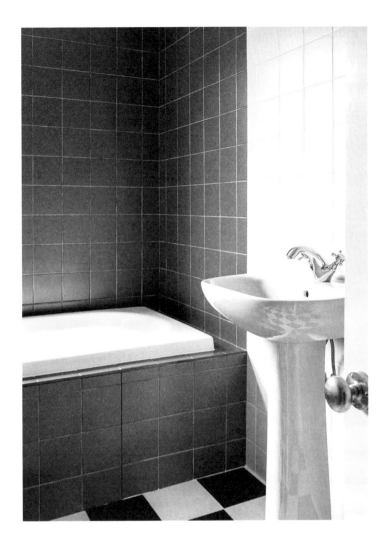

'I know that my colour
choices are polarising,
and I'm ok with that!'

Bathroom tiles have been used to
create zones. The bath is framed
with teal, the shower enclosure is
yellow, and the toilet and sink walls
are mint; it's like creating mini rooms
within a room.

Emily

Ringing the changes with a fully immersive, block-colour backdrop and regularly updated accents in uplifting hues

Emily Brooks' home is packed with personality and people. She lives her with her husband Josh, their two boys, a lodger, a dog called Bear, Pudge the cat, and two bunnies named Sandy and Pandy. She loves to indulge her passion for colour in every aspect of her home, which she describes as 'an eclectic life projected onto a block-colour backdrop.' For Emily, home is a space for 'warmth, laughter, fun, chaos, colour, tears, friends, food and honest life.' She insists that 'If your home stresses you out more than it lifts you up, something needs to change.'

Having once believed that injecting colour into the home meant nothing more than introducing a few bright throw cushions or prints, Emily soon realised that true impact requires full immersion. Recalling the first room she painted in a colour other than grey, she says, 'I knew I wanted Inchyra Blue by Farrow & Ball, but didn't have the guts to just slap it on and "spoil" the new white walls. What if it didn't look good?! What if it was too dark?! I was so nervous.' But she took the leap, and it was a transformative experience.

The inspiration for Emily's scheme comes from the mood she wants to achieve in each room, as she believes colour vibrates with energy that has the power to enhance both the practical and emotional functions of a space. Block colour is used confidently on the walls, with skirtings in the same hue and ceilings kept white – but don't be deceived by the simplicity of the look, for careful planning has gone into choosing colours that complement each other as you move between rooms. And Emily ensures the scheme never gets tired by changing accent features regularly – flowers, soft furnishings and ceramics – creating mini makeovers.

By painting the hallway a deep terracotta, Emily transformed what would have been a dark channel into a warm and inviting passageway. The lilac walls in the reception room have turned it into a fun space, perfect for crafts and playtime.

125

'If your home stresses you
out more than it lifts you up...
something needs to change'

Navy blue paired with lilac creates a
sophisticated, modern feel and is an
unexpected but highly successful
combination for the kitchen, being
good colours for unwinding.

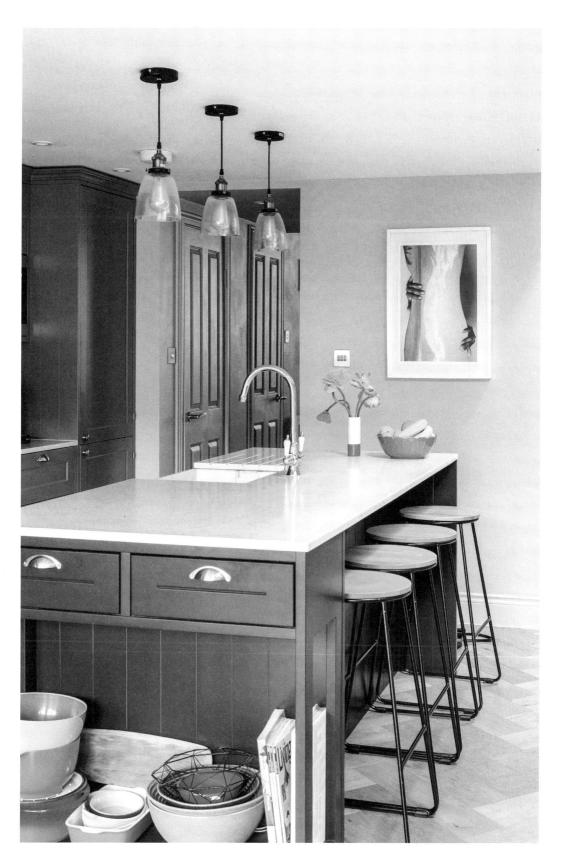

(Above and opposite) The loft bedroom is a large space with lots of light, and Emily has embraced this by using a gentle dusty green that has a soothing effect, adding pops of bolder colour in furniture and accessories. The matching thread of Prussian blue on the table and in the artwork ties the two together and gives a harmonious feel.

(Right) The restful blue in the boys' bedroom can be ramped up or down by switching out accessories and changing accent colours.

Lindsey & George

Quirky Margate home combines beachy pastels and stripes for a fun take on seaside style

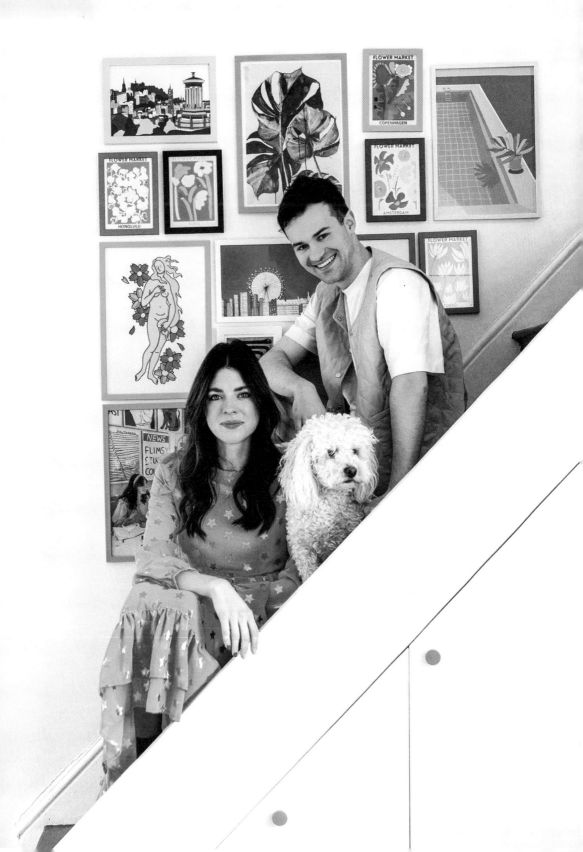

George Pelham and Lindsey Isla Henderson, who work in the worlds of music and fashion respectively, have curated a home in the hip coastal town of Margate that reflects both of their passions. Lindsey laughs that their home has been compared to a Barbie house, and while she doesn't wholly agree with the label, it's undeniable that the space is a pastel paradise, infused with soft pinks. But it has a far cooler vibe that sets it apart from the bubble-gum world of the famous doll.

The pastel palette is a nod to the fashion industry trends that Lindsey was immersed in when they designed their home, while George found inspiration from music album artworks, and the Neapolitan ice cream tones are befitting of its seaside location. They both feel that these colours have had a positive psychological impact, and the green lounge was specially designed to help them relax and switch off in the evening. It is north-facing so needed a dense colour, but, while the green is vibrant, it is softened by the blush pink sofa and accessories.

The couple's joint vision is minimalist with a focus on functionality, resulting in a space that is both chic and liveable. Light was very important when planning the scheme, and Lindsey incorporated lots of mirrors to maximise the reflection of natural light. Pastels are balanced with expanses of white, as seen in their bedroom, where sky blue was chosen for the lower half of the wall, with accessories in lilac, yellow and pink adding a fun Dolly Mixture vibe. Lindsey loves that their home has its own unique character, and muses, 'I think a house almost tells you what it wants or needs to be, and our little terrace suits being cute and quirky; however, another house elsewhere might want something more grand.'

The bedroom is a joyful splurge of candy colours – Parma Violet, Sherbet Lemon and Strawberry Twist – set against a soothing sky-blue wall. The half-painted wall adds interest without overwhelming the space and gives the illusion of height.

A consistent palette of green and pink can be seen throughout the downstairs, including the lounge, kitchen, hallway and studio. Unifying the colours across these spaces contributes to a sense of continuity and harmony. An especially vibrant shade of green helps dial up the brightness in the north-facing lounge.

'I think a house almost tells you what it wants or needs to be, and our little terrace suits being cute and quirky'

(Opposite) The punchy dark green stair allows walls to be left plain white for displaying colourful artwork, and the saturated hue helps to conceal any imperfections in the woodwork.

(This page) George's music studio walls are covered in carpeting, a nod to Elvis's iconic Graceland. Green and pink stripes across the walls and ceiling create an optical illusion that makes the room feel larger.

Francesca
& Robert

Ramping up the joy with layers of graphics
and pattern, inspired by pop culture
and a passion for pink

Francesca Kletz is an interior and textiles designer and Robert Strange is a short-form director, so both have a great understanding of how colour and pattern can be used to create mood and atmosphere. Their penchant for pink informs nearly every room of their flat, and even those who were originally doubtful about such a scheme have been converted.

The couple were keen for their home to reflect their personalities and interests, and Francesca explains that it has ended up being 'The amalgamation of all our trinkets and travels, lives past and present pushed together to form some sort of whole.' They wanted to create a playful, joyful space where they can walk through the door and be confronted with the colours and things that make them feel happy, and every corner of the flat is filled with objects that tell a story.

For Francesca, 'Everything starts with one colour, and I build from there – if it's a piece of trim or ribbon I've found, a button or a piece of furniture, everything stems from that point.' They cleverly use pattern in conjunction with colour, and in the kitchen and bathroom square grid tiles balance the flat blocks of wall colour, while in the bedrooms floral wallpaper and curtains add softness to what could otherwise be a blocky room. In the lounge, the carefully curated gallery walls provide interest, with trinkets and treasures displayed alongside; toys, religious artefacts and hand-sewn embroidery give a personal touch to each room, and using a single colour on the walls creates a backdrop that avoids the space feeling cluttered.

The warmth of pink walls and the coolness of blue kitchen units (as seen on the previous page) give balance to their space. To add an element of surprise and excitement, a rubber floor in a bold chartreuse colour is a lively contrast to the rest of the room.

141

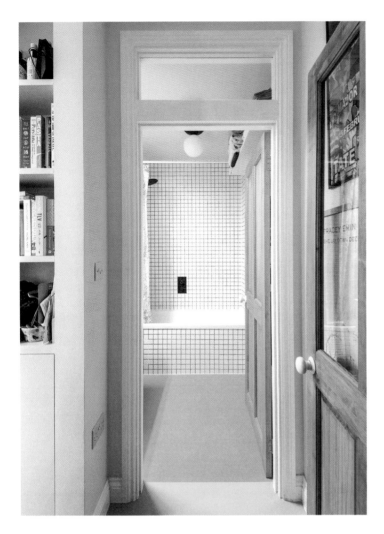

'Everything starts with one colour and I build from there – if it's a piece of trim or ribbon I've found, a button or a piece of furniture, everything stems from that point'

(This page) Pattern is balanced with areas of flat colour, as seen here in the bathroom, where gridded wall tiles are offset by an expanse of wall and floor colour.

(Opposite) In the lounge, pink gallery walls play host to colourful eclectic artwork, retro gig posters and framed fashion editorials.

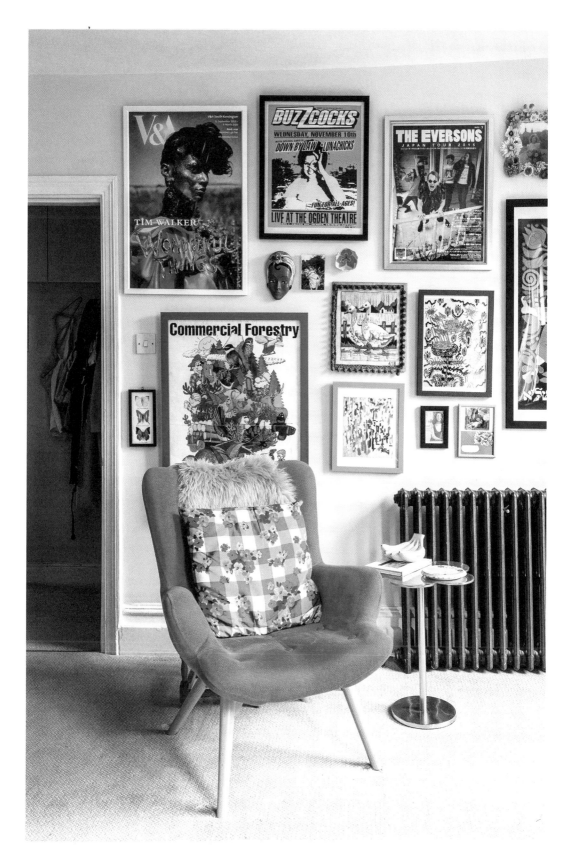

Anna

Utilising an emotional palette to help
define different areas of the home,
from soothing to seductive

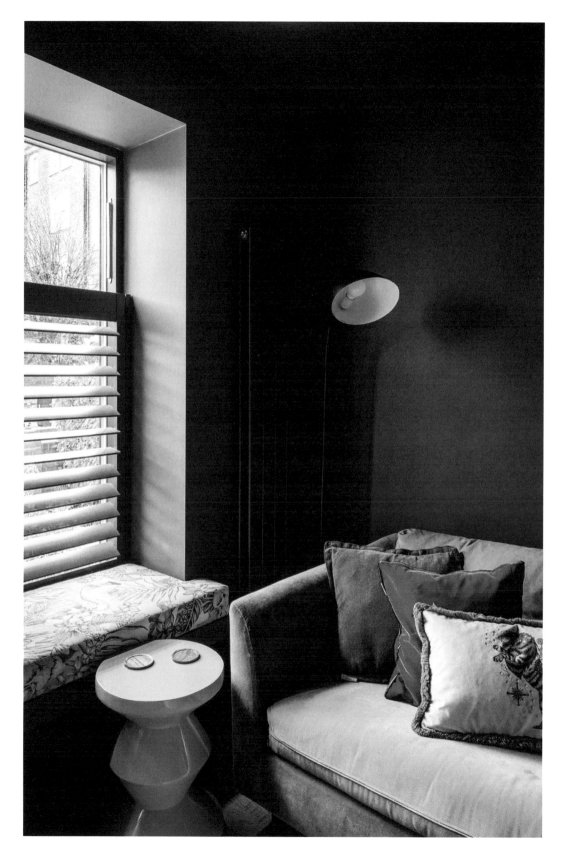

Artist and interior design consultant Anna Proctor has completely transformed her Battersea home. She lives in a renovated 1950s ex-council property with her husband John, their kids Rufus and Scarlett, and their dog Hebe, and colour plays a crucial role in creating joy in their surroundings. 'I love areas of intense colour and pattern,' she says, 'with pops of colour among more neutral yet highly textured areas.'

Anna chooses colour instinctively, while considering the light and mood of the room. She emphasises the importance of texture for bringing visual interest and warmth to a space, particularly when working within the constraints of a limited palette. This comes through in her use of exposed brick, raw plaster and soft velvet. She has used muted colours – inspired by the couple's time living in the Balearic islands and the Bahamas – of turquoise, teal, pink and dirty pastels throughout the house to maximise the feeling of light and space, with bursts of colour in the children's bedroom and playroom.

The north-facing living room presents a departure from this, and Anna explains that 'The living room is much moodier in feel due to the lack of natural light, so we painted the walls and ceilings dark, which makes it very cosy along with the wood burner and emerald-green sofa.'

The sunny journey through Anna's home ends in the loft conversion, where natural materials take centre stage. From the raw plaster walls in the master bedroom to the wooden exposed ceiling and bespoke oak drawers and wardrobes, there is a feeling of authenticity and craftsmanship. The raw plaster adds a unique texture and softness that is perfect for a bedroom, and together with the pale beams creates a wonderful sense of calm.

Often it works to lean in and embrace the cosy qualities of a low-light area. The colour-drenched lounge with its deep, inky walls is instantly relaxing and cocooning, and jewel-coloured soft furnishings prevent the mood from feeling too sombre.

147

'I love areas of intense colour and pattern, with pops of colour and more neutral yet highly textured areas'

(This page) The light-filled kitchen and dining extension are a playful blend of modernist aesthetics with a Californian influence. The fitted cupboards seamlessly connect the kitchen to the hallway and hide away the utilities.

(Opposite) Anna has complemented the raw plaster walls of the bedroom with pastel-toned soft furnishings for extra chill factor. The downstairs toilet is a tranquil pink powder room.

Trish

Muted background colours allow the
bright primary pops to come to the fore
in this eclectic and stylish interior

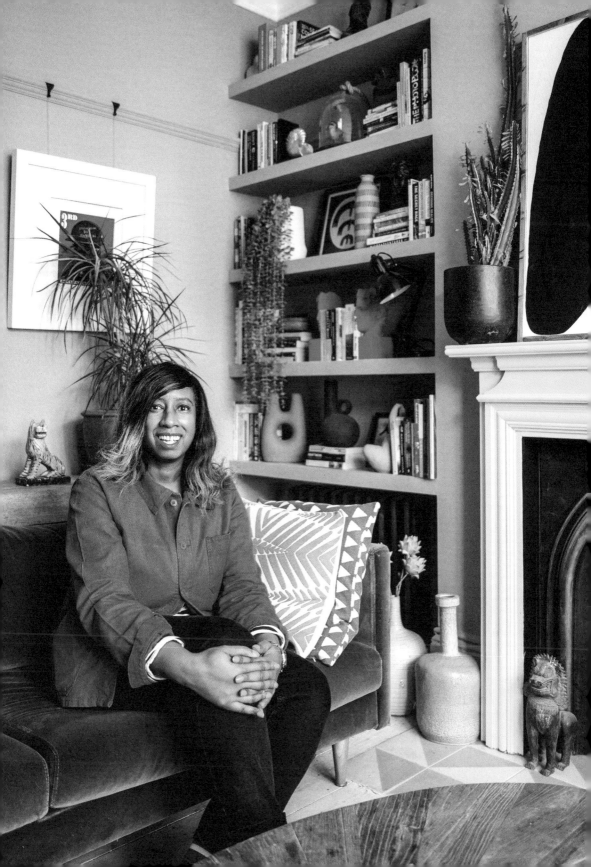

Trish Thomas has turned the traditional three-storey Victorian townhouse she shares with husband Dan and their ginger cat Ozzy into an inviting space that combines original features with modern elements in a way that defies categorisation. Rather than following trends, she revels in mixing different styles, creating intersections where mid-century modern meets Scandi chic, and where bohemian flirts with utilitarian.

Colour plays a significant role in Trish's work as a digital innovation expert, and she explains that 'Colours define visual hierarchies, guide user interactions, and create memorable experiences.' These principles could equally apply to her home, where she strategically selects colours to encourage particular moods and actions. In the master bedroom, dark grey with blue undertones creates a restful ambiance, perfect for a good night's sleep; the mossy green units and dusty rose walls of the kitchen help the space feel grounded and comfortable, encouraging you to linger around the table.

Trish has carefully curated a palette that combines mid-tones and slightly murky hues with pure bright colours. 'I love to embrace yellows, reds, pinks and greens – as long as the shades have a muddy undertone', she explains. 'They are a constant presence, reflecting both my Caribbean heritage and my fascination with urban landscapes, growing up in an industrial town.' She employs accents of stronger colours on cupboards, fireplaces and ceilings, rather than drenching the walls with these, and vibrant colour pops come from the oversized painted canvases, plants and ceramics.

(This page) Injections of pure colour are delivered through graphic canvases, some painted by Trish, some collected on her travels, which mingle with treasures discovered in junk shops or stumbled upon on eBay.

(Over the page) The east-facing lounge is bathed in bright white morning sunlight and can accommodate a wide range of colours. Trish has used a muddy nature-derived palette, from mushroom to moss green, which allows the sunny yellow of the fireplace to sing.

152

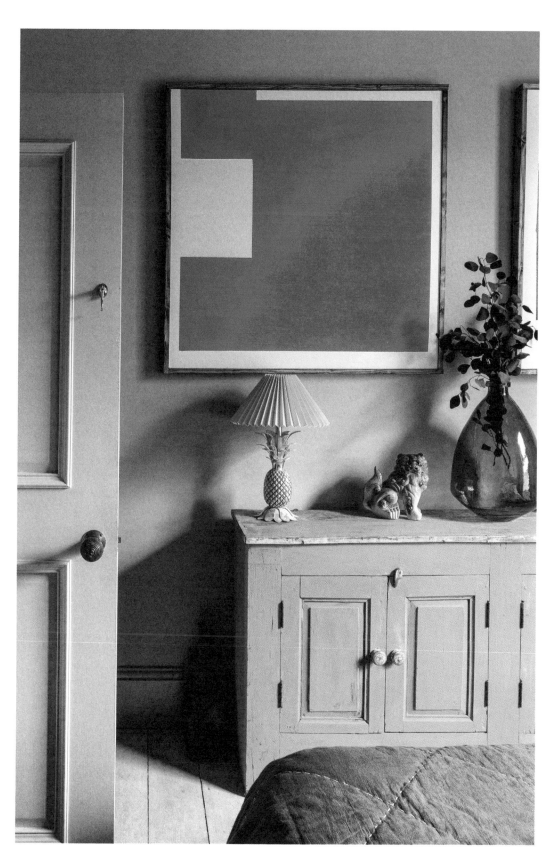

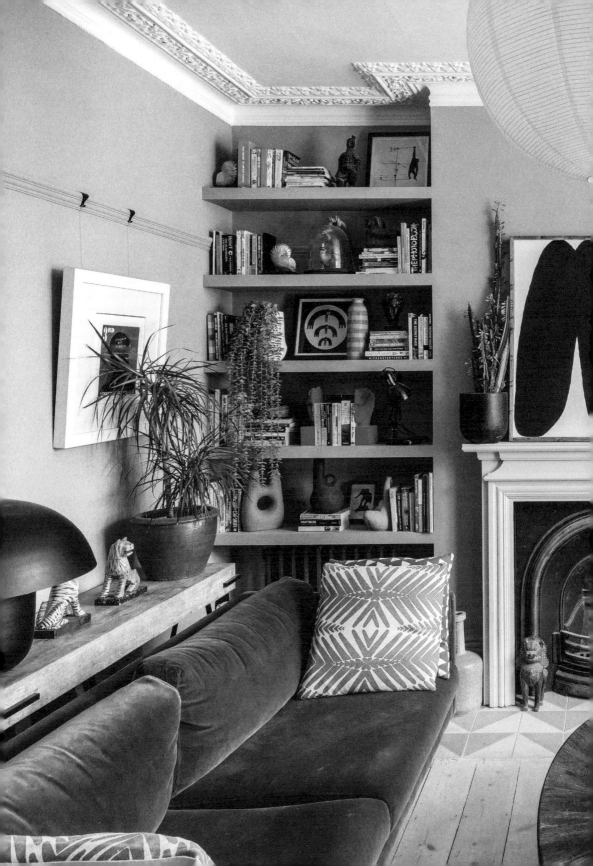

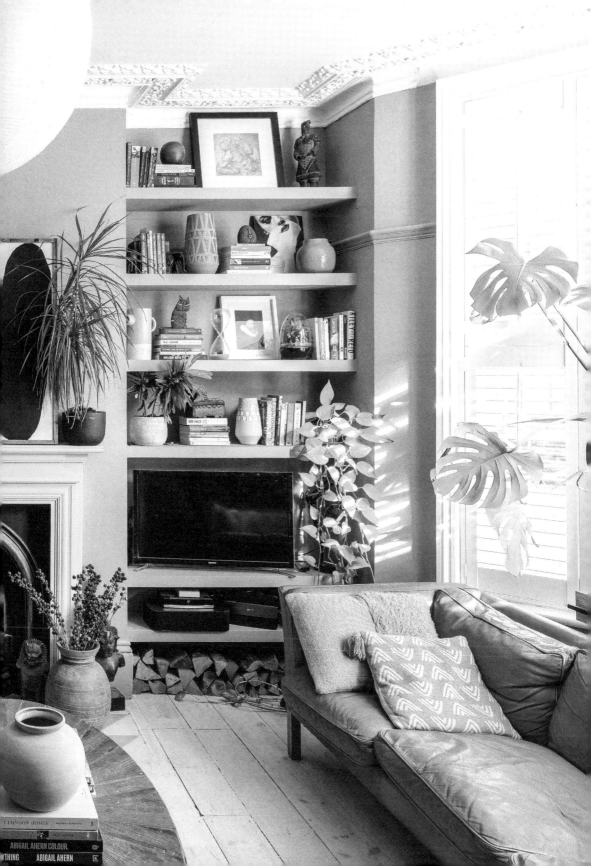

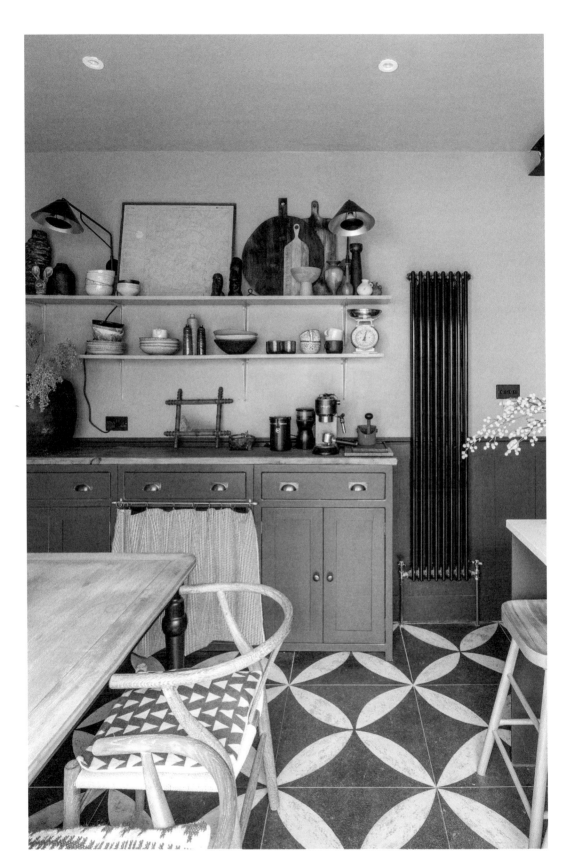

'I love to embrace yellows, reds, pinks and greens... They are a constant presence, reflecting both my Caribbean heritage and my fascination with urban landscapes'

The kitchen has been transformed from a damp and dark room into a sunlit space, opening onto a sunken courtyard. Trish carefully considers where to use stronger colour for maximum impact. The subdued palette of the kitchen feels rustic but sophisticated, and elsewhere bolder yellows, reds and greens cut through the sedate scheme.

Earthy neutrals, with a dark ceiling that draws the room in, are perfect for creating a restful ambiance in the bedroom. In the bathroom, inky walls make the space feel safe and enclosed, with the roll top bath providing a joyful splash of colour.

Emma

Dusky tones combine with texture,
pattern and print to create
a chic and polished interior

Bringing colour to the home doesn't have to mean painting all of the walls in myriad hues. Most of Emma Gurner's downstairs living space is actually brilliant white, and she adds colour with furniture, textiles and accessories, which can be easily updated. Emma is the owner of interior design company Folds Inside, and lives with her husband Rob, daughters Darcey and Florence, and their miniature schnauzer Tiger in a home that feels both sophisticated and fun. 'My aim has always been for it to be a happy space for me and my family', she says. 'I'm not precious about it, it is there to be lived in, it's not a show home.'

Emma has always trusted her instincts when it comes to colour. She understands the effect it can have on her psyche, and chooses the palette for her home according to how she wants each room to make her feel: 'Our living room, with its green sofa and colourful art and accessories, is an uplifting place and helps me feel energized and positive. Upstairs has a softer palette. Our blue bathroom is so calming, and the perfect space to unwind.'

When building a scheme, Emma considers all of the elements in the room and has often used art as a starting point. She always creates mood boards to visualise how these different elements will work together and determine the colours and proportions that will best suit the space. The artworks she has collected over many years bring depth and colour to a room, but most importantly they bring meaning, as each piece is associated with a special person or memory.

The soft colours in the children's room are uplifted with bold artwork and a colour blocked storage area for showcasing vinyl records, while the swing seat adds a fun dimension.

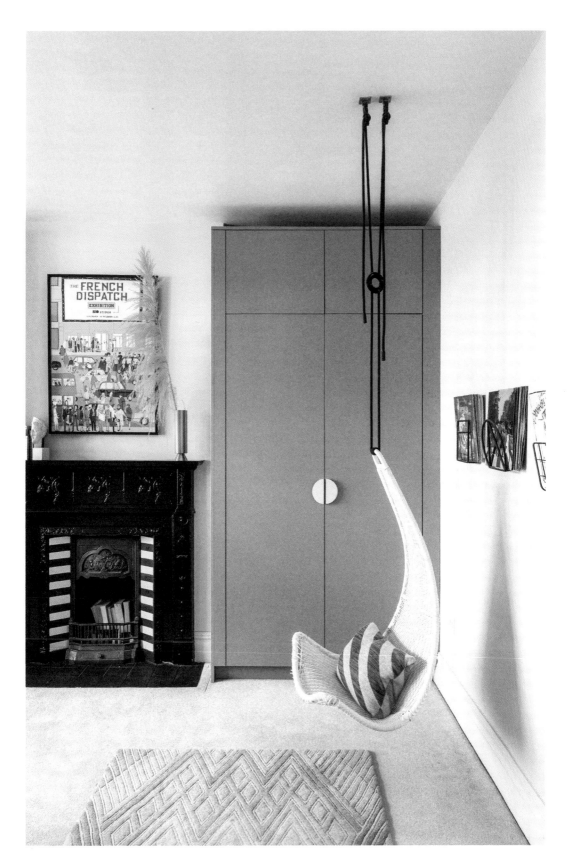

(Opposite) Emma uses pattern in a measured way, and connects the colours in the wallpaper with the walls and woodwork. This can be seen in one of the children's rooms, where the leafy wallpaper chimes beautifully with the rest of the room.

(This page) In the lounge, colour is incorporated with graphic art, and texture with the lacquered cabinet, which elevates the room and gives it a luxe feel.

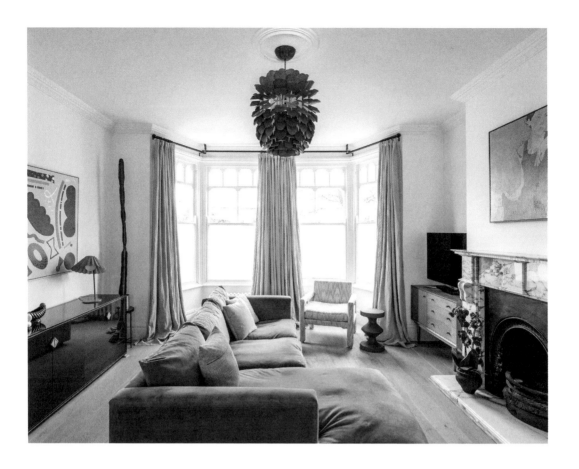

'My aim has always been for it to be a happy space for me and my family. I'm not precious about it, it is there to be lived in, it's not a show home'

(This page) White maximises the light in the room and provides a blank canvas for the colourful furnishings and accessories, which bring depth and warmth to the space and prevent the room from feeling cold.

(Opposite) The pale blue bathroom is designed for unwinding. Zellige tiles, handmade and known for variations in their colour and tone, add interest.

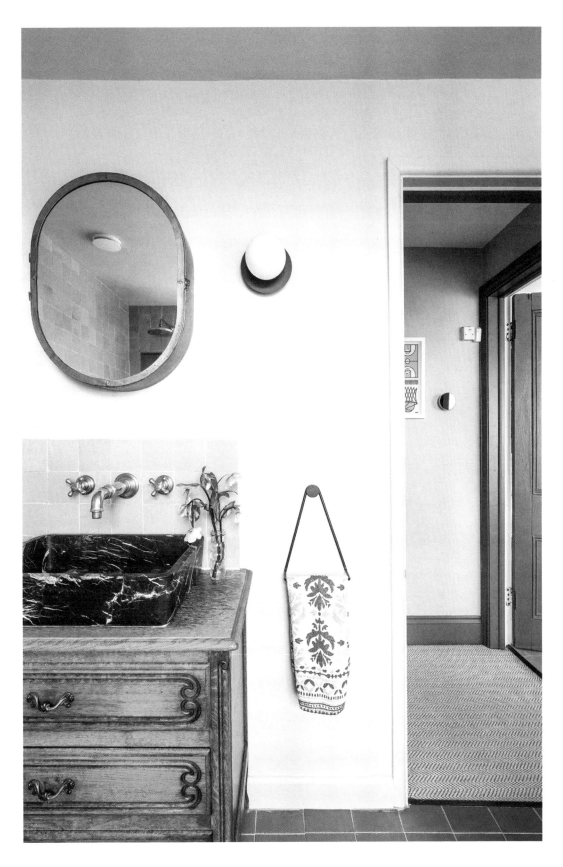

Lee
& Becky

Bold colours set against pastel pink
and neutrals creates a cool 1970s
Californian vibe

Lee Bamsey and Becky Knighton only moved in together at the beginning of the pandemic in 2020, and they immediately took on a renovation. This would be a relationship challenge for most, but they loved it. Lee is a film director and visual effects artist, and they also write and make films together, so they enjoyed the collaboration and their similar design tastes meant that compromises were minimal. They see their home as a visual representation of their personalities, and as telling the story of their relationship.

The couple's design ethos is centred around injecting bold colour that is balanced with neutrals, and you can't miss the bursts of bright yellow and cheerful 1970s orange around their home, from the retro-inspired oven and radiator to the walls of their loft room. As Becky puts it, 'Is there a better colour than orange? It's so happy and fun, which is how we want people to feel when they are in our house.'

Lee and Becky's love of Palm Springs style is apparent, and while they may not be living in their dream Californian resort-inspired home just yet, they have managed to bring elements of the look to their London abode. They've blended mid-century pieces with pastels, palms and personal mementos to create a space that feels both cool and one of a kind. 'We want our friends and family to feel instantly like it's a space they can relax,' Becky concludes, 'but also, when people look around, there is something a bit unexpected that catches their interest, sparks a memory, or starts a conversation.'

In the lounge, a cool 1970s vibe is created with teak shelving and retro furniture, and colour comes through in accessories and in the collections of retro trinkets and treasures.

171

'When people look around, there is something a bit unexpected that catches their interest, sparks a memory, or starts a conversation'

The yellow colour blocking in the hallway is a playful touch that not only generates excitement but also creates an optical illusion of more depth and space. In the kitchen, a pop of pure orange provides a bolt of energy and continues the theme of blending bold and neutral colours.

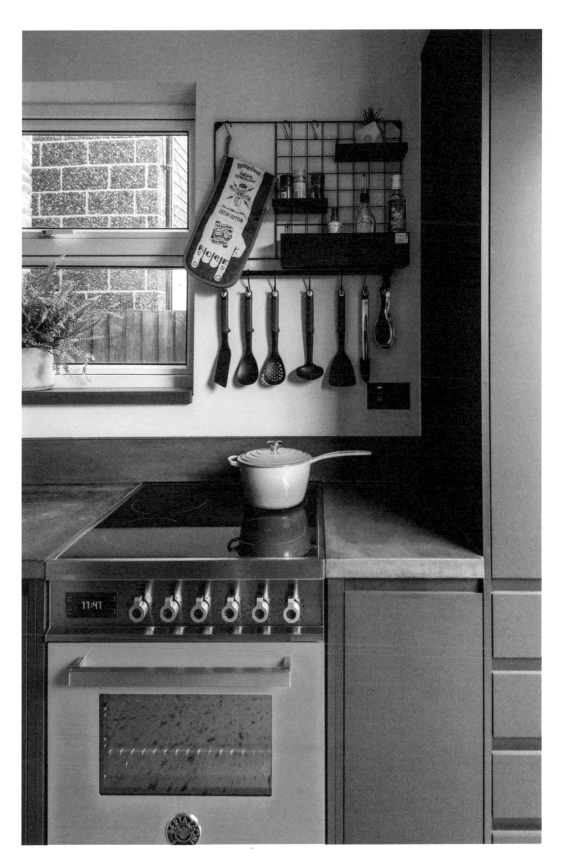

Zoe

Layering all the colours in the
crayon box for an interior scheme
that hums with positive energy

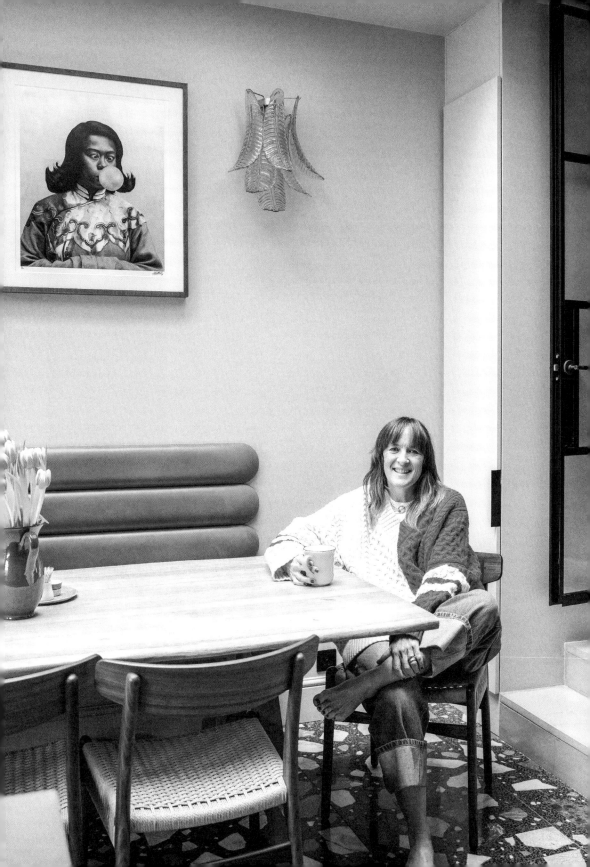

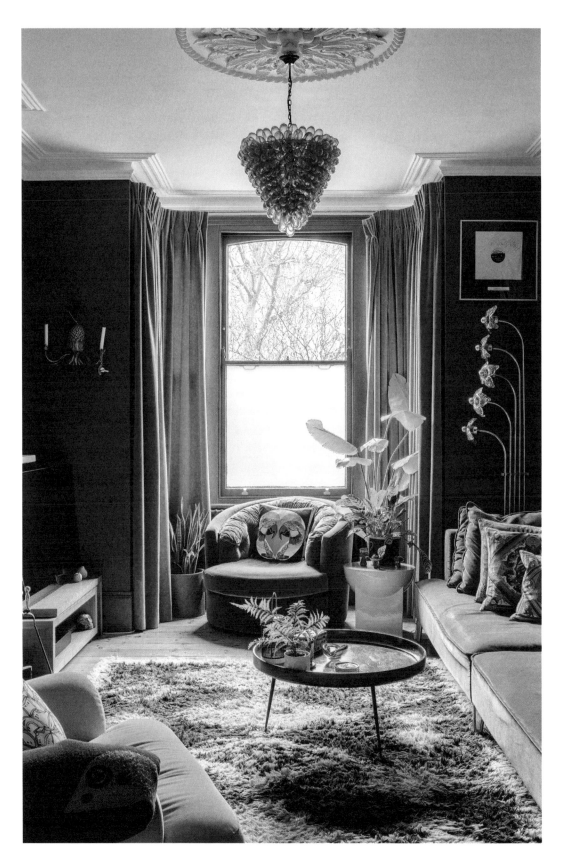

Zoe Anderson is passionate about interiors and works for design-led estate agency The Modern House and Inigo, having previously owned an inspirational homewares store. She lives with her husband, Gavin, and while their daughter Ruby has moved out, she frequently still joins them around the kitchen table. Their home exudes comfort and is brimming with personality (Zoe laughingly declares its personality to be 'the drunk aunty at a wedding'). She uses Gavin as a sounding board and appreciates his insights when she ventures too far into unconventional colour choices – or, as she describes it, 'goes rogue', having once painted a kitchen electric pink and a bathroom in gold leaf.

Zoe draws inspiration from many different sources: the kitchen design, for example, was influenced by the dining room at Luca, a beautiful Italian restaurant in Clerkenwell. She's also inspired by fashion editorials and enjoys exploring how different colours work together, collating photos of combinations that catch her eye – whether in fashion spreads or in nature – and paying careful attention to the balance between light and dark.

Firmly believing in the power of layering colour, Zoe adds playful bursts of brights through accessories such as vases and cushions. 'My ethos is colour loves colour,' she says, 'so you shouldn't be afraid to take risks with the odd pop from a vase or a cushion. Accessories always add a playful patchwork to any scheme.' Indeed, some of the most delightful aspects of Zoe's home are the cherished pieces she has gathered over the years. Whether it's unique artwork, textiles or colourful glass mushrooms, she thrills in finding unusual items that she feels a personal connection to.

The living room is painted a dark hue that remains lively and inviting thanks to the grass green velvet curtains and vibrant artworks, while soft velvet sofas and shaggy rugs amp up the comfort level.

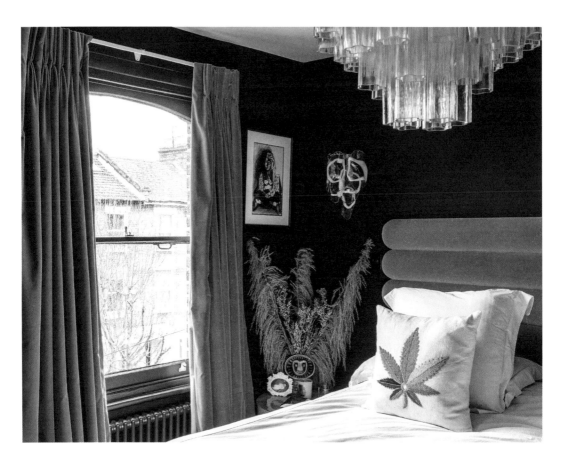

'My ethos is colour loves colour,
so you shouldn't be afraid to
take risks with the odd pop from
a vase or a cushion'

(This page) The bedroom has very
dark green walls (wonderfully
conducive for sleeping), but the
electric blue curtains and head-
board add an unexpected zing.

(Opposite) Zoe places great
emphasis on the floors in her home,
recognising their ability to transform
a space. The floor tiles in the kitchen
are a bold choice, and light pink on
the walls and ochre in the upholstery
complement the terrazzo chips.

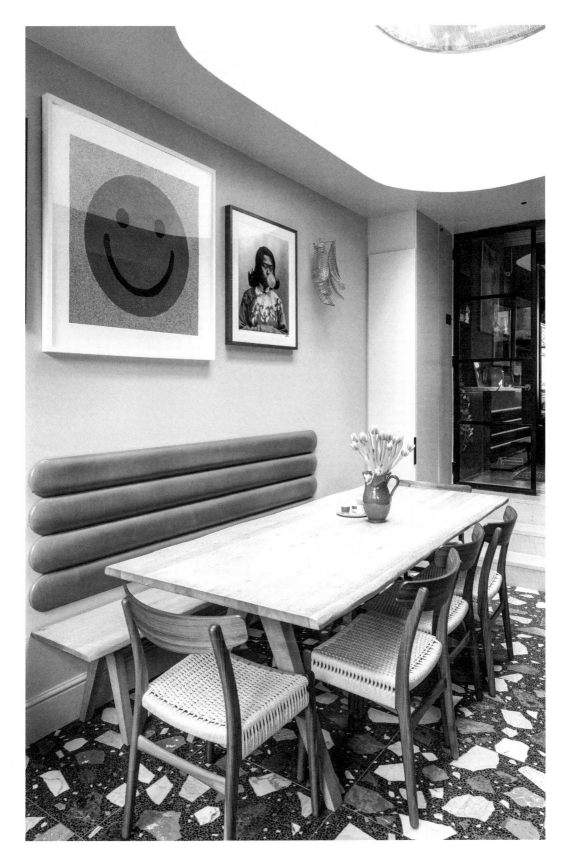

Zoe loves to layer colour and never underestimates the impact of details in a scheme: in the hallway, the vibrant mandarin orange of the stair carpet is repeated in the artwork and flower; in the bathroom, distortions and variations in the handmade tile give interest; unusually shaped striped planters echo colours in the terrazzo floor.

181

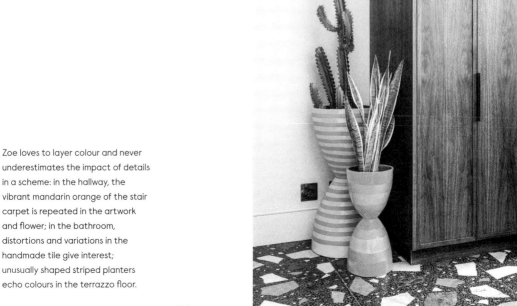

Harriet & Sam

Blocks of primary brights are used
to create different zones and make
a big impact in a small flat

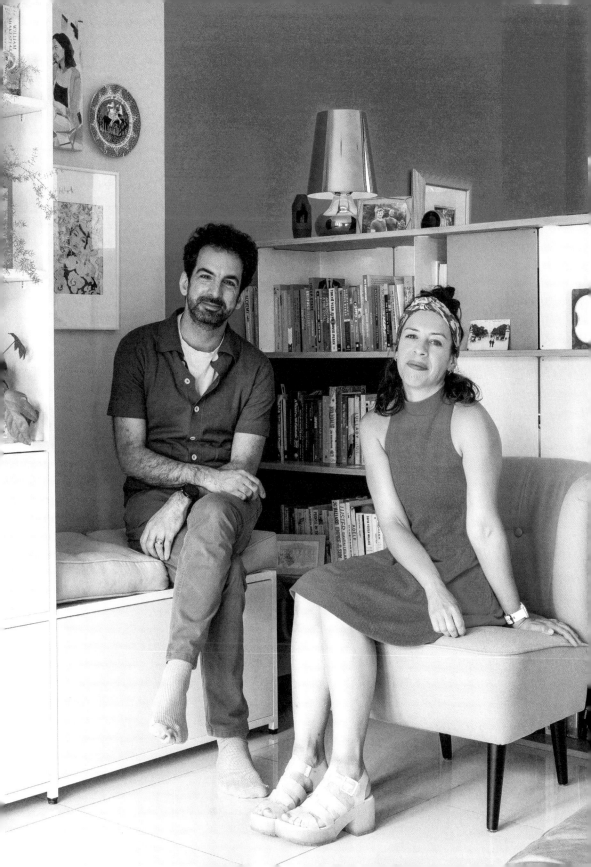

Harriet May and her husband Sam Bourke have transformed their small mews flat into a versatile space that caters to their ever-changing needs. Describing their home as vibrant and busy yet organised and cohesive, Harriet admits, 'We demand a lot from its small space', which includes entertaining guests, exercising and working from home. For them, the ultimate joy is being able to provide a warm welcome to friends, and the colours they've used have been a great talking point.

They have applied bold colours in the living room to create distinct zones for the kitchen, living area and home office. 'Having four different colours for four walls reflects lots of different feelings and possibilities all at once', says Harriet. The spectrum of hues can be both calming and energising, mirroring one's mood. She believes no colour is too much or inappropriate, as long as it is used in the right way. The colours she has used are big and juicy, but when applied in large blocks they don't over-whelm but create an illusion of multiple rooms and – surprisingly – actually make the space feel bigger.

The couple are inspired by items that have meaning to them, including artwork from friends and mementos collected on their travels, such as a Ganesh mask they bought on a trip to India. They embrace change and experimentation with enthusiasm, and are firm believers in the philosophy of 'more is more'. Having made the decision to completely drench their bedroom in red – walls, ceilings, even the radiator and cupboards – Harriet says, 'I'm more likely than ever to take risks, there's nothing that can't be changed or evolved.'

Nestled between two bookshelves, a cosy reading nook invites you to relax, softened with pale pink against the primary colours. A favourite space is the home office behind the bookshelf divide, where the wall is painted a spicy red that gives an immediate mood boost and has an energy that's perfect for an area where you need to get things done.

185

'Having four different colours for four walls reflects lots of different feelings and possibilities all at once'

(Opposite) Painting walls in different colours is a great way to create different zones and moods within a single space. Rather than feeling too much it makes a room seem larger and multidimensional.

(This page) The rich red bedroom has a luxurious ambiance. Colour drenching actually diminishes the intensity of the red, and it's kept lively and energetic with a flash of electric blue on the door and frame.

Emily

Playful pink combined with deeper
colours and graphic patterns makes
a fun and functional family home

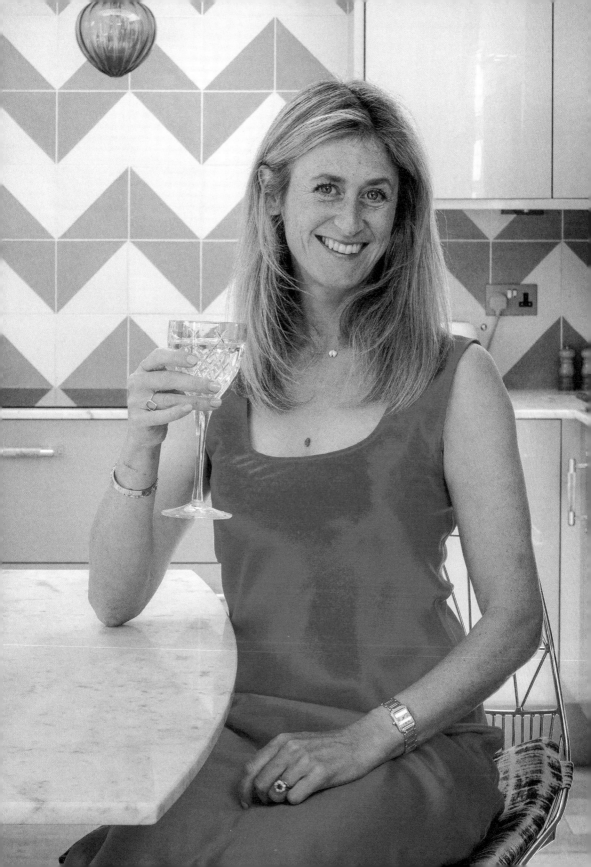

Emily Murray is a writer and content creator who embarked on her blogging journey seven years ago with Pink House Living. Her colourful background as a former magazine editor, national squad gymnast and stunt woman (yes, you read that right) is reflected in her home. While pink is the dominant colour, she's managed to tastefully incorporate it, striking the right balance between playful and sophisticated in the stylish abode she shares with husband Ewan and their sons Oscar and Zac.

When working with her architects, Emily had a clear vision of what she wanted: extensive storage, fun elements, lots of light – and lots of pink. 'There's something about pink,' she says, 'just the right amount of it used in the right way in the right place makes me happy.' She always knew that she wanted to incorporate her favourite colours of pink, blue and green into the scheme, and instinctively knew they worked well together. She recognised their versatility and ability to complement each other in different combinations.

Throughout each room, patterns of all kinds are repeated, from chunky zigzag tiles to leafy palm-print wallpaper and foliage pattern cushions, and integrated into the overall design scheme by picking out colours from the core palette. Colour and texture is always thoughtfully balanced – in the lounge velvet curtains add luxury, while a pink wall behind an open cabinet adds dimension and acts as a backdrop for her books. The contrast between intricate patterns and the simplicity of the wall colours provides visual variety. Emily stresses how much accessories can have an impact, adding that fresh flowers are her favourite because 'The colours pick up on different aspects of the room and make me appreciate other colours in the space.'

Deep blue walls create a cosy and intimate atmosphere in the lounge, while the pink and green accents keep the space lively and cheerful. The selective use of pattern is particularly effective set against bold expanses of colour.

Emily

(This page) Candyfloss pink gives a soft, boudoir feel to the bathroom, especially when paired with gold hardware.

(Opposite) The juxtaposition of bold tiles and floral wallpaper works harmoniously in the kitchen as they keep within the limited palette of pink and green, set against pale blue cabinets. The gold handles and bar stool add a luxe feel.

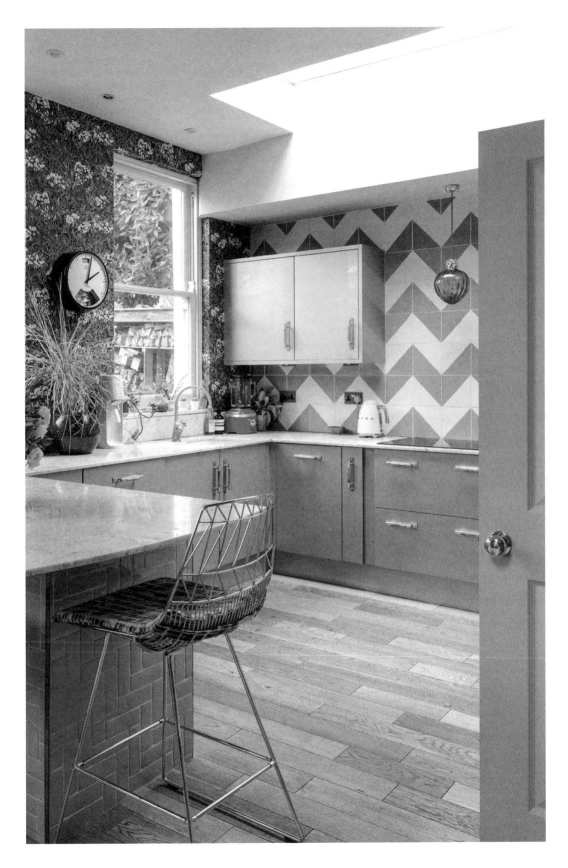

'There's something about pink... just the right amount of it used in the right way in the right place makes me happy'

(Opposite) The hallway has a big impact when you walk in, with Crittall windows pulling light through into what would otherwise have been a poorly lit space. Every corner of the house encourages interaction, from the climbable storage to the trapeze swing in the lounge.

(This page) Velvet, brass and leafy foliage bring texture, adding dimension and stopping the dark walls from feeling flat.

Barbara & Adrian

A mood-boosting scheme that explodes with an unapologetic love of colour and pattern

Barbara Ramani is the creative force behind the vibrant home she shares with husband Adrian and their two boys, Jackson and Lennox. She has transformed a 1940s house, which she says 'Lacked architectural details and had low ceilings, narrow doorways and dark spaces' when they bought it, into an expressive wonderland of colour.

Their hallway had been dark and dingy: 'It is the spine of our home so my journey from room to room was always punctuated with a sense of doom!' explains Barbara. She adores vivid colours, asymmetrical patterns with strong contrasts, and the interplay of irregular shapes, and decided to bring all of this into the scheme for this area. Now she loves to watch her boys run up and down the colour blocked staircase: 'The colours make me feel really calm and it fills me with a sense of satisfaction that I managed to design and execute such a complicated mural.'

Barbara draws inspiration from postmodern art, architecture, and interiors, but also clothing and objects: her living room colour palette was inspired by her favourite trainers in burgundy, yellow, candy pink and powder blue, and her husband's office by the core colours he likes to wear.

One of the rooms she is most pleased with is Jackson's bedroom, where, inspired by his request for rainbows, Barbara created a fun, imaginative space. Jackson gives names and personalities to the colourful shapes and blobs adorning his walls – 'king of blobs', 'pickle', and 'dark shadow' being just a few. The wonderful reciprocal result of Barbara's creativity has been to encourage her children's creativity. But Barbara's favourite room is the snug; bathed in abundant south-facing light, it features dark purple walls and shelves filled with an organised chaos of collected objects in pink, cobalt blue and lilac to energise and uplift her.

(Previous page) Barbara pulls three colours through the downstairs space, envisioning the walls, ceiling and floor as one continuous piece of art. She incorporates one or two accent colours across soft furnishings, artwork and lighting, always ensuring a balance of light and shade.

(This page) The rainbow-inspired wall mural in her son's bedroom uses paintbox colours and fun shapes to encourage creative interaction.

198

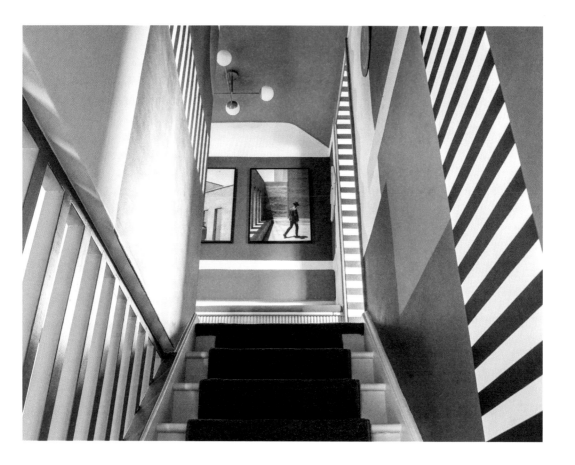

'The colours make me feel really calm and it fills me with a sense of satisfaction that I managed to design and execute such a complicated mural'

Barbara incorporated her love of both colour and asymmetric design into the staircase mural. She loves sitting at the top of the stairs on the hallway bench, holding her boys after their bath time and taking in the marine colours.

(Over the page) The south-facing snug receives plenty of light and can take the strong purple colour. The narrow door was replaced with a velvet curtain that blends seamlessly into the shelving carpentry.

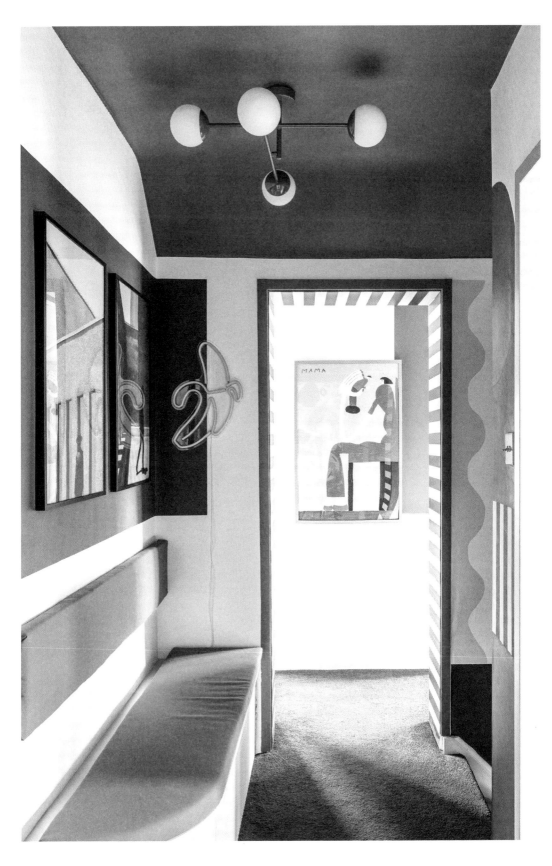

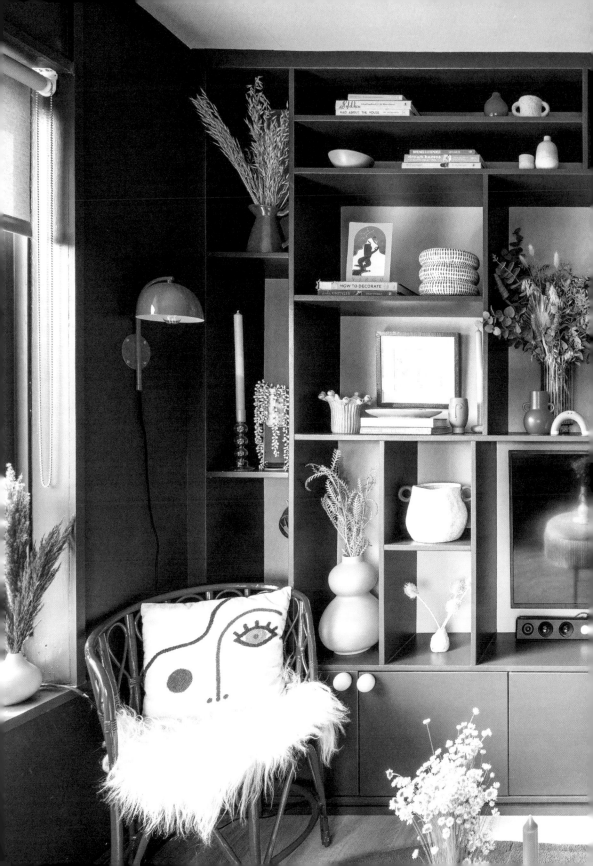

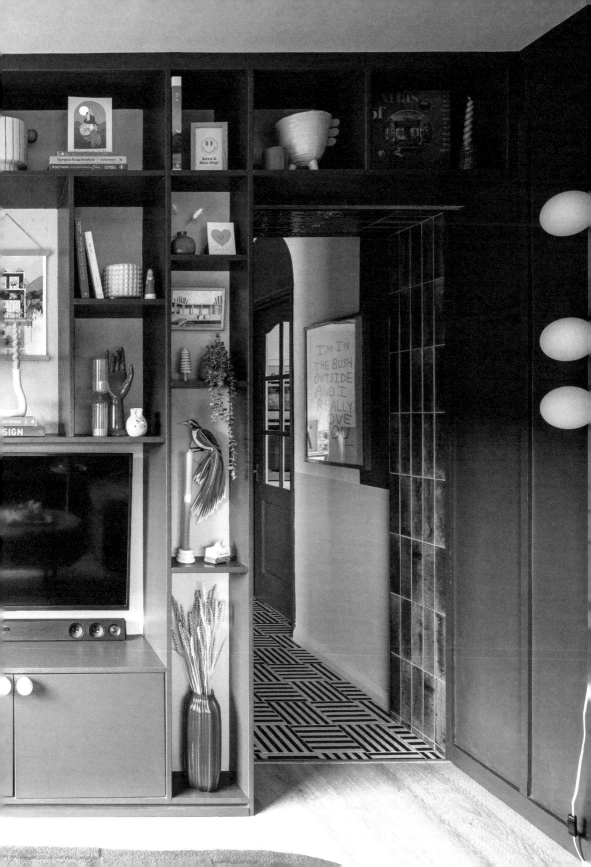

Each room has different elements that amuse and delight. The colourful wall mural is repeated in the window study nook of her son's bedroom, while hand-painted triangles add interest to what would otherwise be rather ordinary window frames in Adrian's office.

Tina
& Ian

Heritage colours, inspired by nature
and cherished possessions, maintain the
vintage vibe of this Edwardian home

Tina Koniotes and Ian Chater's home is a carefully considered mix of jewel tones, layered prints, cherished objects and art. As the founders of Cera, a luxurious home fragrance brand, they are very aware of the importance of ambience, and like to follow the advice of founder of the Arts & Crafts movement William Morris, who famously declared, 'Have nothing in your houses that you do not know to be beautiful or believe to be useful.'

Drawing inspiration from different eras and sources – including art, vinyl records, books, vintage handbags and collected objects – each room tells its own story: the luxurious pink in their lounge was inspired by a pair of red glass vintage vases, while the original idea for the blue of the hall came from the vibrant hues of Morocco's Blue City. When deciding on a palette, they purchase sample pots in multiple shades of a colour and paint them onto A4 sheets of paper: 'We stick these painted sheets on different parts of the room, living with them for a few weeks to observe how they interact with the light. Only then do we make a final decision', they explain. They found they loved every one of the samples they had stuck on their kitchen wall, however, so ended up using them all in different areas of the kitchen and utility.

Friends and family weren't initially encouraging of their choices, and would commonly ask, 'Why not just paint one wall if you have to use that colour?' Undeterred, they've been painting their walls in jewel tones for over 25 years, even when the trend has been for neutral palettes: 'Although the colours in our home are vibrant and loud,' says Ian, 'they still make us feel relaxed and comfortable, and evoke happiness whatever room we are in.'

(Previous page) The loft studio has abundant light thanks to three large glass sliding doors. Walls are painted a deep green shade that changes with the light and pairs well with the exposed brick and wood.

(Opposite) Tina and Ian initially thought about using purple for the lounge walls but decided on warm red, inspired by a vintage cranberry vase. They added purple in the form of a velvet sofa, with cushions and throws providing accents of hot pink, turquoise and green.

'Although the colours in our home are vibrant and loud, they still make us feel relaxed and comfortable'

Blue features greatly in the house. The hallway and stair are drenched in floor-to-ceiling Lapis blue, inspired by Chefchaouen in Morocco. The master bedroom is a serene period blue, painted from picture rail to skirting and keeping the area above the rail crisp white to give the illusion of added height.

Gwen & Patricia

Stepping outside of their comfort
zone to create a colourful, light-filled
home that exudes happiness

This retired couple has transformed their house into an exciting and inviting home that radiates warmth. When they embarked upon their renovation journey, these former law practitioners knew that colour would play a pivotal role. Reminding themselves that repainting was an easy fix if needed, Gwen Williams and Patricia Lynch took the plunge with colour. The result shows their courage and willingness to step outside of their comfort zone. Choosing colours can be an anxiety-inducing process for many, but their architects played a crucial role in empowering them to embrace the potential of vivid hues.

Gwen and Patricia also encouraged each other to be courageous and embrace their shared vision. They say they have become less risk-averse over the years, defying convention and creating a home that is a true reflection of who they are. Both reveal that their favourite colour combinations are the pinks and greens, with Gwen adding, 'The loft stairway with the acid green handle set against the vivid pink is always a joy to see, especially with the skylight and the shadows that are cast.' They also appreciate how the colours connect, enjoying the vistas from the loft stairwell into the soft blue of the bathroom, or looking through to the front garden from inside.

Every corner of Gwen and Patricia's home demonstrates the power of good design, from the mesmerising arch roof light in the kitchen to the stunning 3D tiling on the sides of the island, the vibrant patterned sofa to the bright red stair, and a reminder of how colour can add drama, character and excitement. The terracotta and teal cabinets in the kitchen complement the earthy floor tile, and are a comforting combination that sets the tone of their home. 'We love the colours, and they enhance our life because they make us happy', says Gwen.

The bedroom is in restful shades of lilac and blue, opening out onto an energising flood of colour from the loft stairway. What could have been a nondescript passageway is given a sense of drama.

215

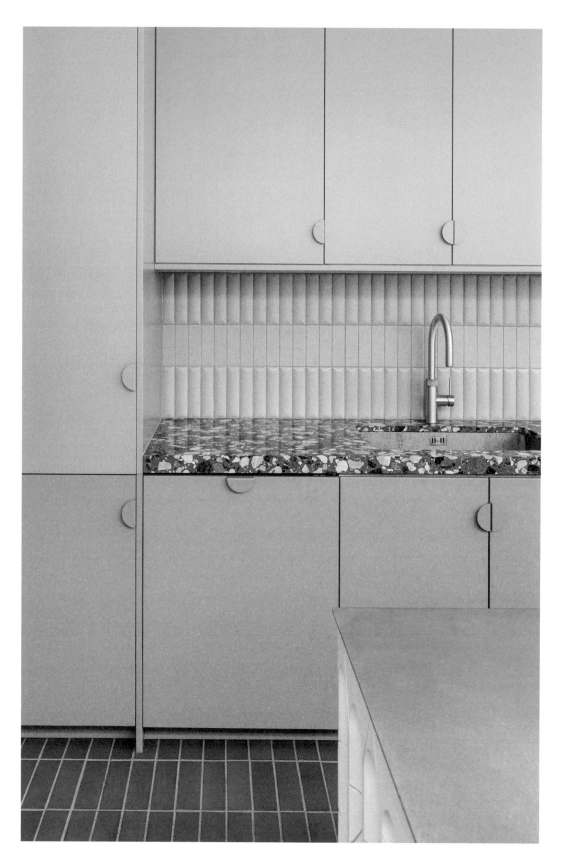

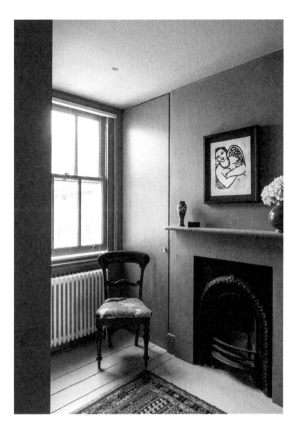

(Opposite) There is plenty of interest in the kitchen, with colourful cabinets in terracotta and teal, 3D tiles and a vibrant terrazzo countertop that picks up on the cabinet colours.

(This page) Several rooms are colour drenched, taking the colour across ceilings, walls and cabinets to produce a fully immersive effect that can feel moody and dramatic, or light and uplifting.

'We love the colours, and they
enhance our life because
they make us happy'

Red can be used to great effect
in big or small doses; the colour-
saturated hallway feels intense and
enveloping, while pops of vibrant red
in textiles and accessories bring a
shot of energy and interest to a
more sedate and soothing scheme.

218

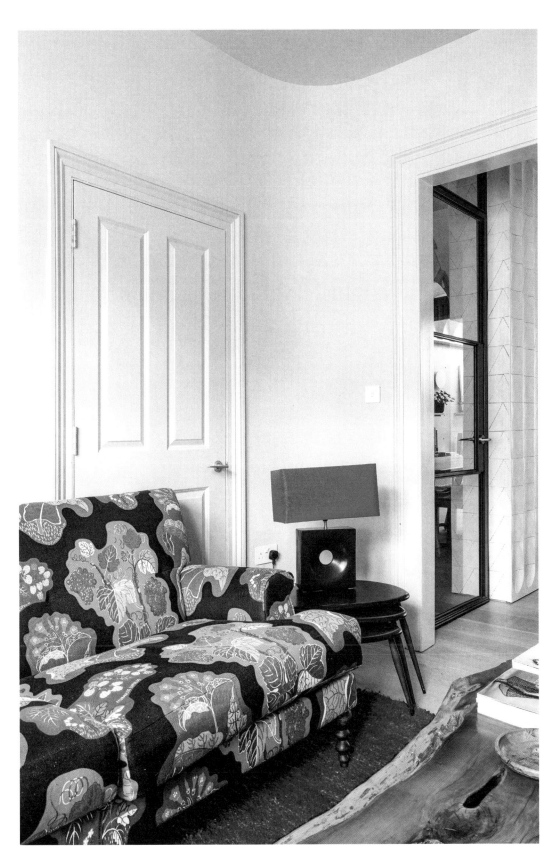

Bo

Radiant bursts of colour cut through
the gloom and bring the sunshine in,
whatever the weather

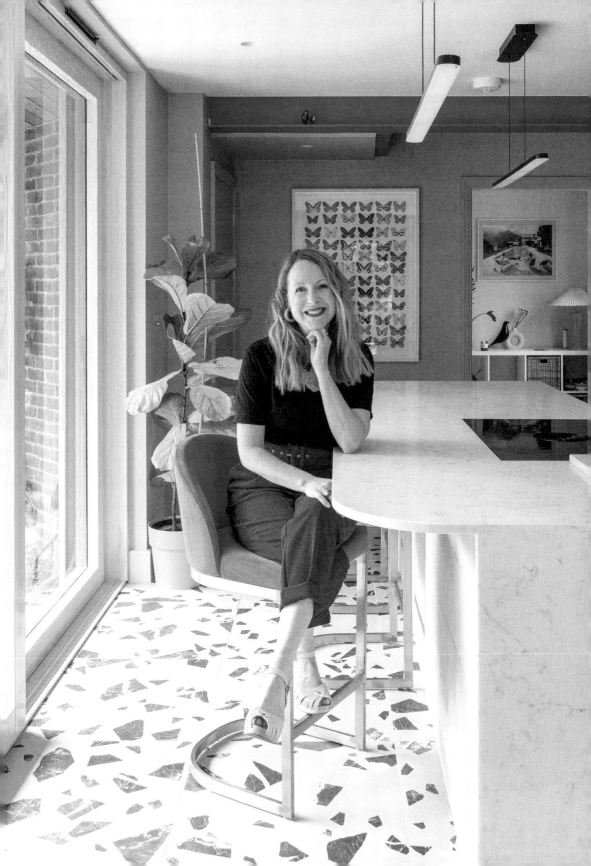

Bo Fentum lives with her husband, twin daughters and their beloved cat Rory in a house that embraces family and fun – and which doesn't take itself too seriously. She is the founder of a residential design studio, and her own home reflects her love of colour and her ability to create spaces that are both functional and individual.

Bo's design journey, both professionally and through multiple renovations of her own home, has allowed her to explore many different styles. 'This house is our third renovation in 13 years, and each one has been different to the last in architectural style', she explains, adding that the common theme has been colour. With the often grey and dull weather in the UK, Bo uses colour to raise her spirits and infuse her home with energy, creating a space that radiates positivity. 'I use colour very much as a mood enhancer, especially during the winter months. I want reasons to smile', she says.

Having always been drawn to colour, Bo has never felt nervous about using it. In fact, she confesses that a neutral scheme makes her anxious. This confidence manifests through-out her home, from the bathroom cloaked in floor-to-ceiling pink to the use of patterned wallpapers and unexpected pops of colour. 'I've always loved American mid-century design and architecture, and been drawn to the colour palette that run alongside it – greens, yellows and pinks', she explains. 'But more recently I've been enjoying the brighter colours of the Memphis Milano design movement. It's inspired me to try brighter pops of colour that punch their way through.'

(Previous page and opposite) The recently completed kitchen has been transformed with sliding glass doors and picture windows to bring more light and connectivity to the space. The chunky pink terrazzo floor makes a statement so has been tempered with earthy toned walls, and bright spots of interest added with soft furnishings and an eye-catching steel beam.

'I use colour very much as a mood enhancer, especially during the winter months. I want reasons to smile'

The wallpaper is a busy pattern so works best in more muted, sophisticated colours, also picked out in the headboard. The transformative power of even a touch of vibrant colour should not be underestimated; the lively yellow pop of a book, accessory or flower arrangement can lift an otherwise sedate colour scheme.

Ella

Mid-century modern design with a
Le Corbusier-inspired palette and
an unexpected Moroccan twist

Ella Jones, founder and owner of Hackney-based homeware store A New Tribe, lives with her husband Magnus, son Kit and dog Peggy in a calm and open space that reflects both her and her husband's aesthetics. With clean lines softened by tactile materials, it feels stylishly mid-century with a Moroccan edge. Ella is inspired by Le Corbusier: 'We loved how Le Corbusier uses colour to break up more open and otherwise minimal spaces, and we wanted to translate this idea in an exciting way into our home', says Ella.

The deep blue wall in the kitchen is one of the most joyful aspects of the interior, recalling a deep Mediterranean sea and acting as a backdrop for the framed rug. This colour is also picked out in accents around the room, such as the vase in a similar tone. 'This hasn't come about in a contrived way,' she says, 'they are pieces that we already had, and it just made sense to put them here. These are collections that we've built up over a long period of time, and each piece means something to us.'

Ella emphasises the importance of seeing how colours look against each wall in the rooms they are intended for, so does lots of swatch painting to see how they react in situ: 'It sounds obvious, but a colour changes depending on the angle that the light hits it, and colours can look really different in different spaces and lighting conditions throughout the day.'

Ultimately, Ella's home is a testament to the importance of being surrounded by objects that have meaning, a story or personal connection. She believes that home should make you feel grounded, and be a calming antidote to the chaos outside. With her considered palette of soothing colours uplifted by bright accents she has certainly achieved this.

The downstairs is all one open space that is used differently throughout the day. The kitchen is a favoured daytime hangout, whereas evenings are spent in the lounge, which takes on a different atmosphere after hours with softly dimmed lighting. The kitchen's vibrant blue connects beautifully with the nude walls in the middle and lounge areas.

228

Ella

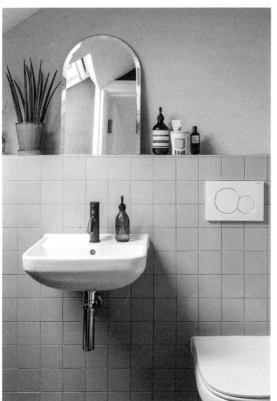

The distinctly Moroccan feel to the scheme is carried through in the Cerulean blue accessories, baked peach tiles and dusty aqua walls, as well as in accents such as dried grasses and cactus plants.

230

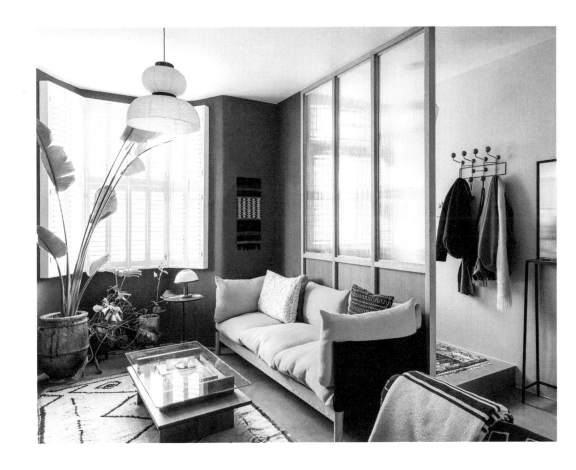

'We loved how Le Corbusier uses colour to break up more open and minimal spaces, and wanted to translate this idea in an exciting way into our home'

Each wall colour connects to the next, with the open plan space anchored by bookend grey walls. The glowing yellow sofa is a cheerful pop of colour which is perfectly balanced by the grey of the lounge and the pink hallway colours

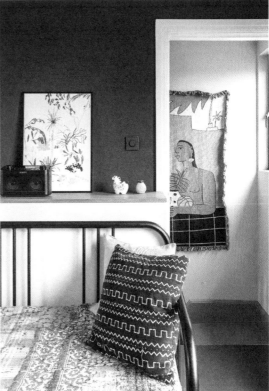

There's a softer feel to the upstairs, with mushroomy colours uplifted by peaches and greens. These earthy colours are restful, and the tightly curated palette gives a harmonious and polished look.

233

Jess

Evocative family home taps into personal experiences to create a rich and colourful tapestry of memories

Jess Alavi-Ellis, a broadcast journalist and content creator, lives with her husband Darius, daughter Remi, sister-in-law Lydia, and two cat companions – Nibsy and Persie. Together they have created a colourful, comfortable and personal haven that captures treasured memories. The colour scheme embraces the power of emotion and nostalgia, with each room a carefully crafted tribute to experiences from their life's journey: 'I love making my home as beautiful as our budget will allow, but far more important are the people (and animals) that fill it', says Jess.

The concept of 'each room is a memory' allowed the family to infuse their home with emotions they wish to relive, providing a perpetual source of joy and inspiration. Jess explains, 'The terracotta walls of our kitchen remind us of our honeymoon in Mexico, the sludgy green and near black in our bedroom of our rainy November wedding in the Basque country.' By tapping into memories, she discovers colours that resonate and feel timeless and personal.

There's a softness to this home, with the palette gently swaying from restful greys and nudes through mid-tones and brighter pops of colour. It's a confident scheme where the colours feel like they've been part of this house forever, but playful elements keep them feel current. Jess consciously blocks out the noise of trends and social media influences when making decisions, focusing instead on the light within each space and the emotional impact she wants to achieve. Colour is not just part of a scheme but a means of transportation to happier, sunnier destinations: 'If you really squint, you can feel like you're on holiday in our kitchen', she says.

Matching the walls to the floor tiles in the hallway elevates it to feeling like a more design-led area. The yellow is a burst of welcoming sunshine upon entering the house, transitioning into a moody blue.

236

'I love making my home as beautiful as our budget will allow but far more important are the people (and animals) that fill it'

Interesting shapes such as bendy lamps, zigzag table legs and curved sofas bring with them a sense of fun and personality, enlivening the restful nude tones used on the walls.

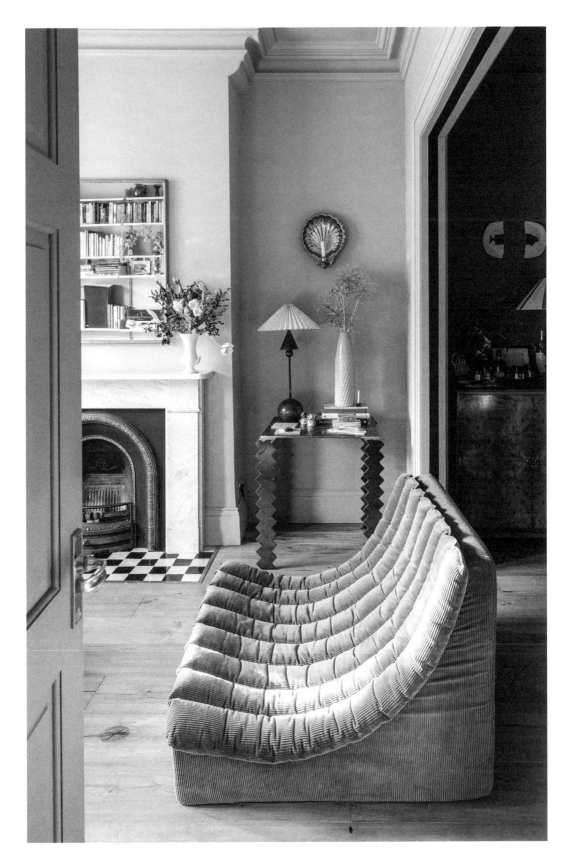

Edwina

A playground of the imagination
where colour and pattern collide in
exciting moments and cosy corners

.

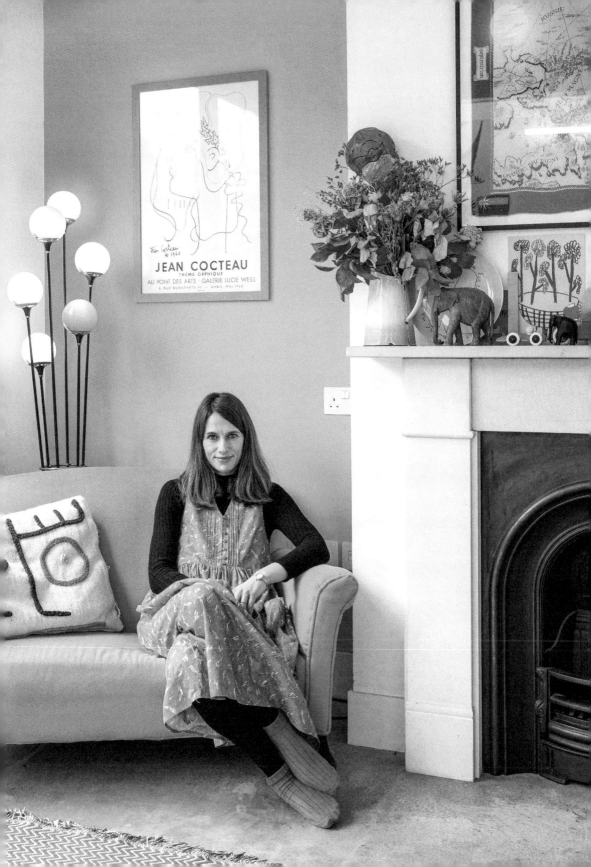

THEY CALLED
HER STYRENE

Edwina Gieve is co-founder of sustainable clothing brand Clary & Peg, and lives in a quirky home with her husband Dan and their four boys. The entrance hall sets a playful tone, its pink and white stripes chosen because they evoked happy memories of Edwina's childhood dollhouse. As you go upstairs, the landing walls alternate yellow and white stripes, which gives a fun sense of the circus and echoes the kitchen's mural of tumbling harlequins.

The kitchen is the most colourful room in the house, and where the family spend most of their time. 'The most joyful aspects of our interior are the mural in our kitchen, inspired by a Hockney print that Dan had in his bedroom as a child, and a cupboard by Fornasetti', says Edwina. 'On a grey January day, our wall of dancing harlequins makes the world seem like a better place!'

There is a connecting thread of bold colour running through the house, but Edwina is unafraid to create a different aesthetic in each room and wanted each space to have its own personality. Every corner has a sense of humour, from lamps that look like balloons to whimsical wallpaper and tile designs. When it comes to making design decisions, she says she grows ever bolder: 'I like the fact that our home is so different. As I've got more confident in myself, I have less of a desire or need to conform.' The joy of this home is that each item has been carefully curated, but everything feels relaxed and the cheerful colours and accessories bring such a feeling of fun.

(Previous page) In a cosy corner of the kitchen, a favourite bright orange sofa is neutralised somewhat with a peachy pink wall.

(This page) The inviting book-filled study/playroom has bold blue walls with accents of pink and orange. The house seamlessly blends vintage with modern, with pieces that have just the right level of colour.

243

Edwina

The kids' bathroom shows how yellow can be used to uplift a space. The simple square tiles have been transformed into a fun piece of art, with a pattern of yellow and white stripes and squares. In the main family bathroom, vivid green lifts the woodwork to create a lively feel and connects beautifully with the tones in the Voysey print wallpaper.

244

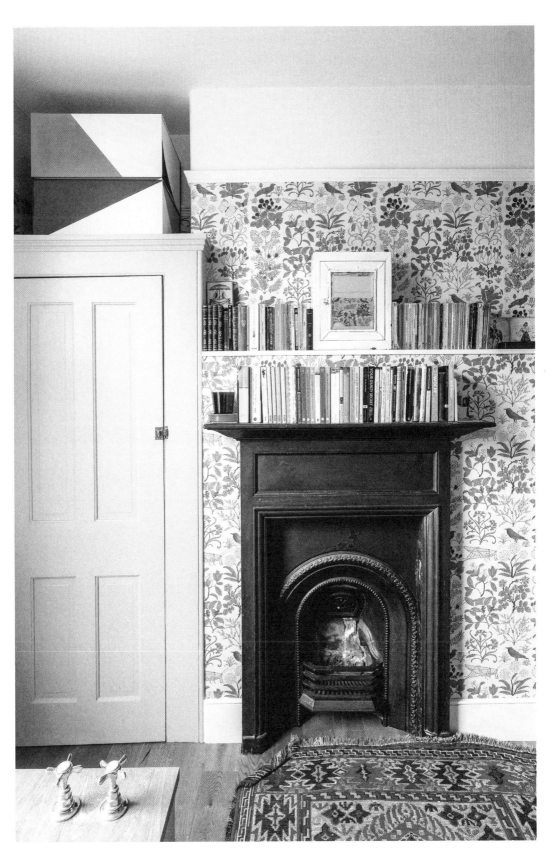

'On a grey January day, our wall of dancing harlequins makes the world seem like a better place!'

Playful features of the home include the dollhouse-inspired entrance hall, and the mural of harlequins in the kitchen extension. Door frames and beams have been highlighted in primary colours set against pastel walls, and the yellow beams of the rooflight lift the eyes skyward and provide a shot of sunshine, whatever the weather.

Tamsin & Ben

Bold, juicy shades are juxtaposed
to create unexpected vistas in this
colour-loving couple's home

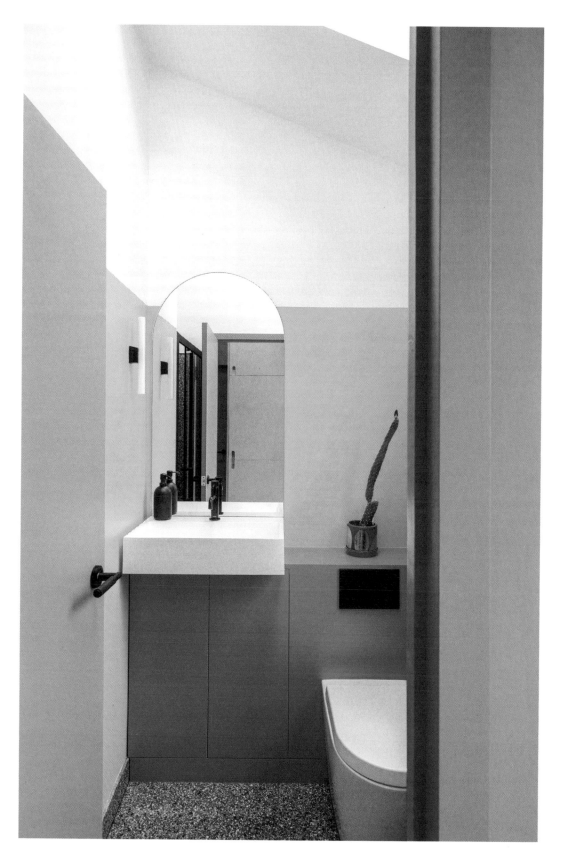

Tamsin Bicknell, a consultant midwife in the NHS, lives with her husband Ben and dog, Mab, in east London. They purchased this ex-council house in 2014, which hadn't been updated or decorated in a very long time and felt like it was stuck somewhere in the 1970s or 1980s. The couple set about renovating, applying their love of colour to create a home that is full of unexpected and enjoyable combinations.

There's a boldness to the scheme throughout, with earthier tones in the living and dining areas and juicier hues in the bathrooms and hallways. Each room tells a personal story, with inspirations ranging from such diverse sources as the Jardin Majorelle in Marrakesh, with its electric-blue art deco studio, to 1990s gel-pen colours. 'There isn't really a theme or cohesive concept,' admits Tamsin, 'it's fairly eclectic.' Of the garden room, she says, 'It was like the green chose itself, as it feels like it's an extension of the garden.' The couple take great enjoyment from knowing that they have designed a home that is totally unique to them, with colours that resonate on a deep level.

Tamsin has been confident with colour since childhood, her mother having given her kids the freedom to decorate their own rooms, instilling confidence and a willingness to take risks with colour. Although not always perfect, these early experiments taught her that it's okay to try different things – and that a room can always be repainted. This affinity with colour has carried through her life, and she says that 'When Ben was once asked what he thought I would buy with a million pounds... his answer was that I would buy and own a colour.'

The downstairs bathroom is a fun fruit salad mix of strawberry, mango and orange, a joyful contrast with the more earthy yellows and greens of the living and dining areas.

251

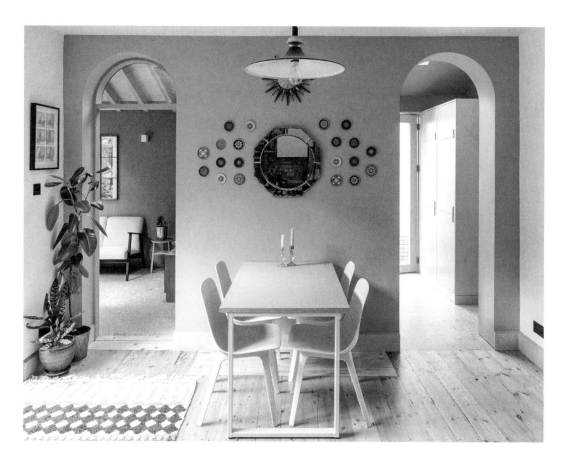

'Ben was once asked what
he thought I would buy with
a million pounds... his answer
was that I would buy and own
a colour'

(This page) Arches provide a
frame for the colours, which work
beautifully when viewed together.

(Opposite) The deep green was an
obvious choice for this room, which
felt like a part of the garden. The
tranquil shade chimes with the
exposed wooden beams, and
accents of cobalt and sky blue
continue the nature theme.

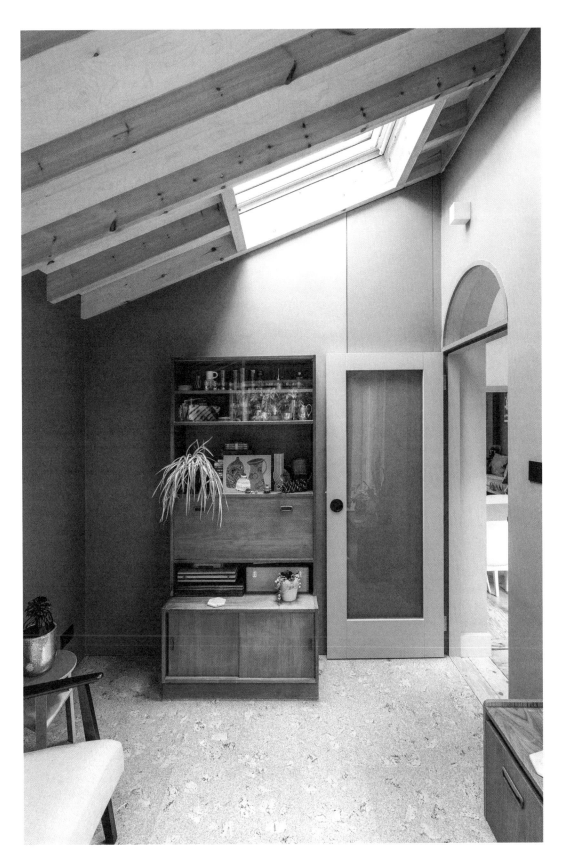

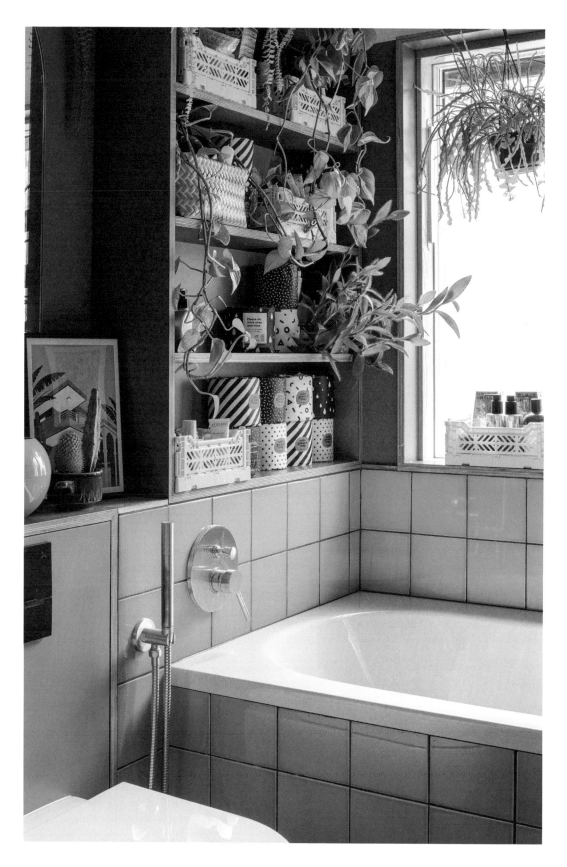

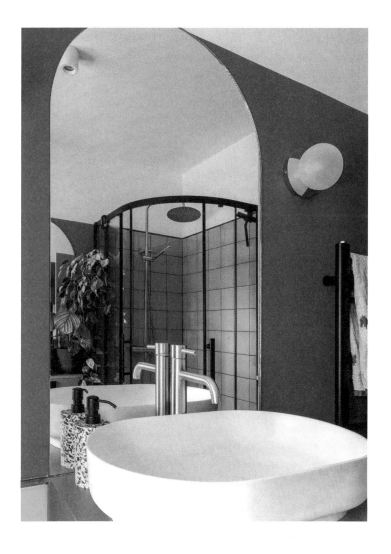

One of Tamsin's favourite spaces is the transformed upstairs bathroom. From cramped beginnings, it was extended into the adjoining hallway cupboard to create a leafy sanctuary in Yves Klein blue. The attention to detail, such as the blue grout contrasting with the yellow tiles, helps create a cohesive scheme.

The New Colourful Home
First edition
Published in 2023 by
Hoxton Mini Press, London

Copyright © Hoxton Mini Press 2023
All rights reserved
Text © Emma Merry, Home Milk
All images © Neil Perry

Copy-editing by Gaynor Sermon
Design and sequence by Richard Mason
Proofreading by Octavia Stocker
Production by Sarah-Louise Deazley

ISBN: 978-1-914314-49-0

Printed and bound by OZGraf, Poland

Hoxton Mini Press is an environmentally
conscious publisher, committed to
offsetting our carbon footprint. This
book is 100 per cent carbon compensated,
with offset purchased from Stand For
Trees.

For every book you buy from our
website, we plant a tree:
www.hoxtonminipress.com

Project credits
Homeowners are largely to be credited for the design and its
application for the homes featured in this book, but we would like
to add the following acknowledgements: Nat & Kat: architects @
smithandnewton; Anna & Denis: architect @james_dale_architects,
construction @rimi_renovations, colour and interiors consultant
Home Milk; Natasha: design @untillemonsrsweet; Emma & Simon:
interiors Emma @triflecreative, all rugs by www.floorstory.co.uk;
Mariam: colour and interiors consultant Home Milk; Ms Pink &
Mr Black, colour alchemist Ms Pink; Lindsey & George: construction
www.theboatfitco.co.uk; Zoe: architects for kitchen extension
www.guyderwent.com; Harriet & Sam: colour and interiors
consultant Home Milk; Gwen & Patricia: architect Bradley Van Der
Straeten @bvdsarchitects, colour advice from Jessica Williamson;
Rob: collaboration with Rhonda Drakeford www.studio-rhonda.
com; Tamsin & Ben: architects Eckford Chong, and special thanks
to Trevor Harris for home-improvement help